Pastel Painting
Step-by-Step

PETER COOMBS, MARGARET EVANS
AND PAUL HARDY

SEARCH PRESS

Contents

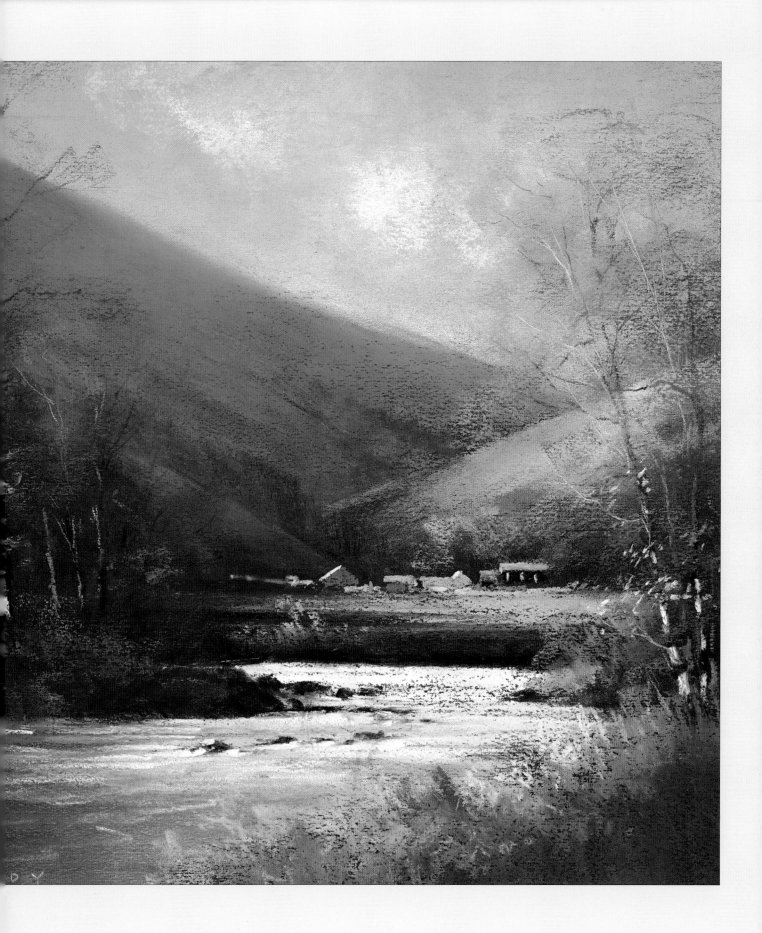

Materials

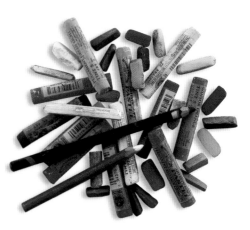

Pastels

Pigment is the common ingredient of all painting mediums; it is the binder that makes the pigment into watercolours, oils, pastels, etc. Buy the best pastels that you can afford. Good-quality soft pastels are almost pure pigment – only a small quantity of gum is used to hold it together – and they have a depth of colour far greater than any other medium. Some cheaper pastels have a lot of binder and do not release colour easily.

There are three basic types of pastel: soft pastels, hard pastels and pastel pencils. They can be used separately, but combining the different types of pastel is part of the pleasure of using them. Soft pastels are the most versatile and flexible of the three. They release the pigment freely, so a light touch is necessary, especially when mixing lots of colours together. Too much pressure will clog the surface and deaden the colour and texture in the finished painting. Use the tip of the stick to make small marks and the side of it for larger areas.

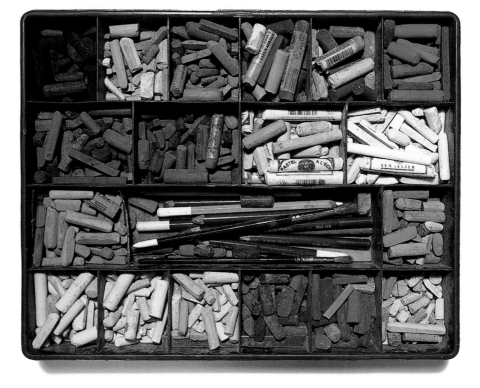

Hard pastels are firmer and less likely to break, but they do tend to flatten and compact the painting surface, making the stick skate across the surface if it is overworked. They are, however, very good for adding final details to a soft pastel painting and are particularly useful as a drawing material.

Pastels are dry and cannot be diluted for mixing like other painting media. However, most pastels are available in a range of tints/ shades of individual hues; the pale tints have white added to the pigment, the dark ones, black. Some pastels come in five tints of each colour – tint 4 is the pure colour, tints 3, 2 and 1 are lighter tones and tint 5 is a darker tone.

Pastels get dirty quite quickly, especially if you work with them in a tray or box beneath your drawing board. If you want to keep pastels clean, try adding ground rice to the box. The ideal box for pastels has compartments into which you can sort pastels according to colour and tone. It should have enough sections for light, medium and dark shades of each main colour. The one shown above belongs to Margaret Evans. It also has a long compartment which is useful for pencils, torchons and knives.

Surfaces

The painting surface (or support) has a vital part to play in the finished painting. There is a huge range of papers to choose from and selection of the right surface is as important as the pastels used. The most important point about the painting surface is that it must have a degree of roughness (or tooth) to hold the pigment released by the pastel stick. There are lots of different brands of pastel paper (smooth on one side and textured on the other), and many artists choose a fine-grade abrasive sandpaper. These abrasive papers have a pronounced tooth that is able to take up a lot of pigment without clogging. If a subject needs a lot of building up, perhaps because it is complicated or textured, it is best to choose a rougher surface.

The effects created by different textures and colours of paper can make a huge difference; choosing wisely can turn an otherwise dull subject into a vibrant painting. Some artists prefer dark or bright colours, as they add vibrancy to the subject. Smoother papers are ideal for portraits, or for sketching. Papers which combine an abrasive texture with a good range of colours are readily available.

Watercolour paper can be used for pastel painting and is particularly useful if you are going to add water to the pastels, as Margaret Evans does in some of her flower paintings.

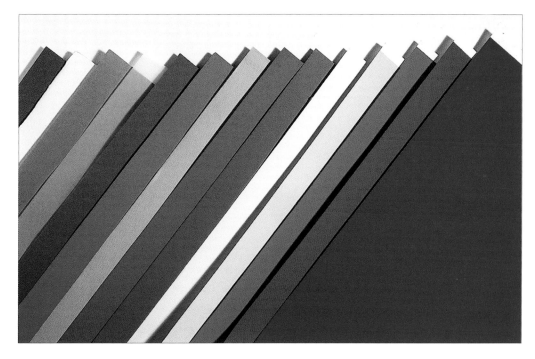

A selection of papers that can be used with pastels, in different colours and textures.

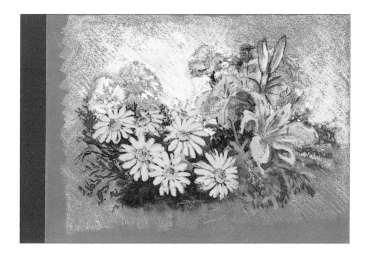

Working on transparent paper can produce spectacular effects. It provides a neutral background for your work, and when you have finished, the fun begins! Slide papers in different colours underneath, and see how they enhance different sections of the painting.

Red paper
This adds a warm pink glow over the painting, and helps to merge the shadows into the flowers in places, giving an altogether softer appearance.

Pastel pencils

For quick sketching, some pastel artists carry a pencil case with pastel pencils and a few soft graphite pencils. Pastel pencils can be sharpened with a craft knife, but not to a point – just expose enough of the pastel core to work with, then use the pencil on its side to wear it down to a point. Pastel pencils can also be used for drawing the basic outlines of a composition. It can be difficult to maintain a good line on the smoother papers. Conversely, on a very rough surface, marks made with pastel pencil can be broken and lack definition.

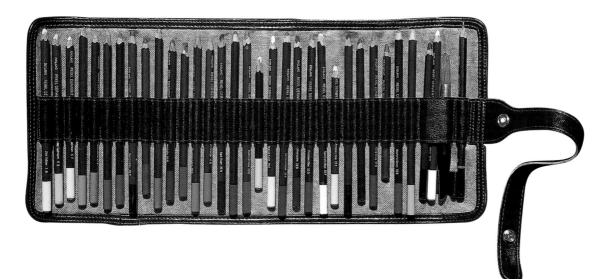

Blenders and brushes

Rubber-tipped blenders can be used to merge pastels, thus avoiding the need to rub them with your fingers, which can make the result very muddy. You can also use a paper stump or torchon (this looks like a pencil with points at both ends) to blend small areas of colour.

To apply water to pastel, Margaret Evans uses synthetic round watercolour brushes (no. 6 and 10) and a flat 2.5cm (1in) brush. The round brushes are great for more directional application, and are used with 'wet' water for diluting colour, or with 'damp' water for intensifying colour. The flat brush is ideal for wetting a large area of pastel to create a broad mass of colour. Keep these brushes separate from your other brushes if you paint in other media – some of the abrasive papers used with pastels would spoil good watercolour brushes. You can also use old bristle brushes for scrubbing off mistakes, or when the tooth of the paper is overloaded with pastel and you want to add more layers. Other 'scumble' brushes and fans are useful simply for scrubbing off pastel.

A selection of blenders, brushes and a graphite pencil

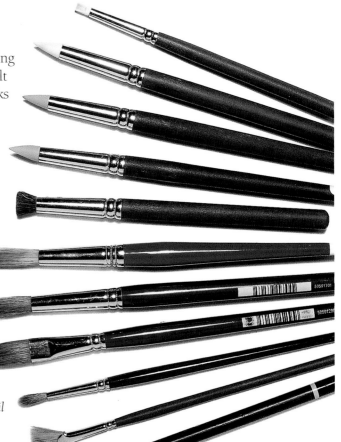

Easel and drawing board

The painting surface should be as near vertical as possible to allow excess pigment to fall away from the surface, so an easel is a must. If you work on a flat surface, the excess dust could make the painting process difficult and you could lose the sparkle and immediacy that is exclusive to pastel painting. Some artists like to stand when painting, but there are some excellent table-top easels for those who prefer to sit.

The drawing board should be smooth and free from bumps or indentations. It can simply be a sheet of plywood or MDF. Some artists use a wooden board in the studio, and a more lightweight board when travelling. You can work on top of several layers of paper for extra protection. Attach the paper to the board using drawing pins, spring clips or masking tape.

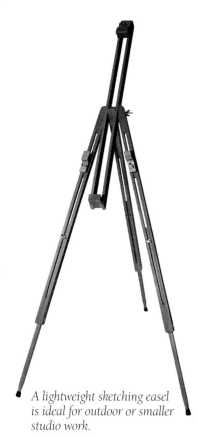

A lightweight sketching easel is ideal for outdoor or smaller studio work.

Other equipment

Spray fixative can be used during the initial stages of a painting to fix the base colours prior to overlaying others. Some pastel artists spray finished paintings with a light layer of fixative when mounting them under glass.

Pastels make your fingers dirty, so use wet wipes or a damp rag to keep them clean. Alternatively, try rolling a small ball of plastic adhesive between your fingers to remove colour.

Use masking tape to stop paper edges flapping in the wind, and to mask off sections of a paper sheet when sketching several scenes on one sheet.

For quick sketching, you will need a few soft graphite pencils. Sharpen pencils and pastel pencils with a craft knife. Use a putty eraser for rubbing out pencil.

Some artists also use charcoal and charcoal pencil with pastels.

A collapsible water pot is handy if you are diluting pastels with water.

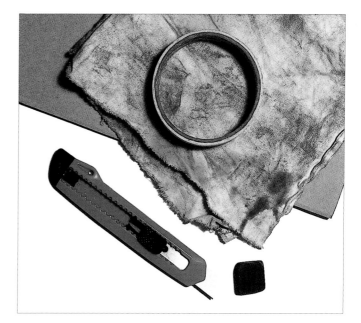

A rag, masking tape, putty eraser and craft knife and (left) a collapsible water pot.

PAINTING WITH PASTELS

by Peter Coombs

Pastels are made from finely ground colour pigments that are bound together with gum and compressed into sticks. The great joy of painting with pastels is the direct and quick way you can transform a sheet of paper into a painting. It is a dry medium, so you do not need special brushes or a supply of water before you start.

Records show that drawings were created with pastels as early as 1685. In fact, many old masters used pastels to create fine works of art that are as fresh today as they were when painted. The popularity of pastels as an artistic medium led to the formation of the Pastel Society in the late nineteenth century, and this continues to thrive today.

In this book I try to dispel the myth that painting with pastels is difficult. Do not worry about whether you can 'draw a straight line' – pastels are very adaptable and, in any case, there are not many straight lines in nature. You can make marks with the pastels and blend colours together with your finger. If you are not happy with the result, you can go over it with other colours.

Everyone develops their own way of painting with pastels. In my mind, there is no wrong way of creating art – so if you get a result that satisfies you it is the right way.

I have included four step-by-step demonstrations to help build up your skills. Take things slowly at first, work lightly and loosely with the colours and you will soon be saying proudly, 'I did that'. So get started and make your marks!

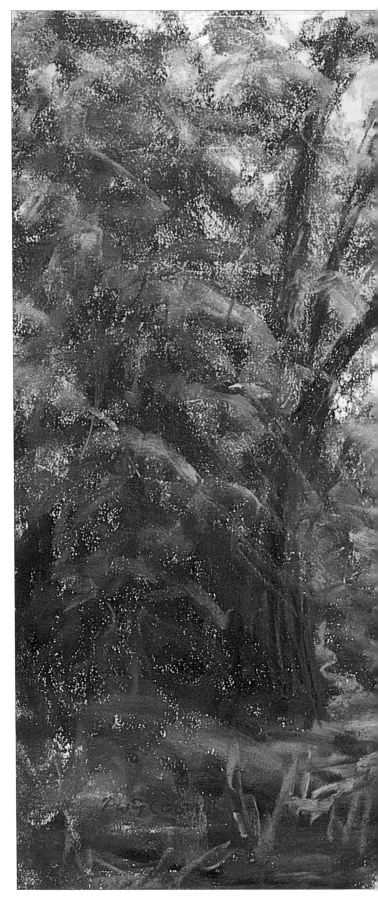

An Evening Stroll
53.5 x 40cm (21 x 15¾in)

This painting portrays form against light. Note how the depth of tone in the foreground leads you to the figures, the point of interest, and then out to the rest of the painting.

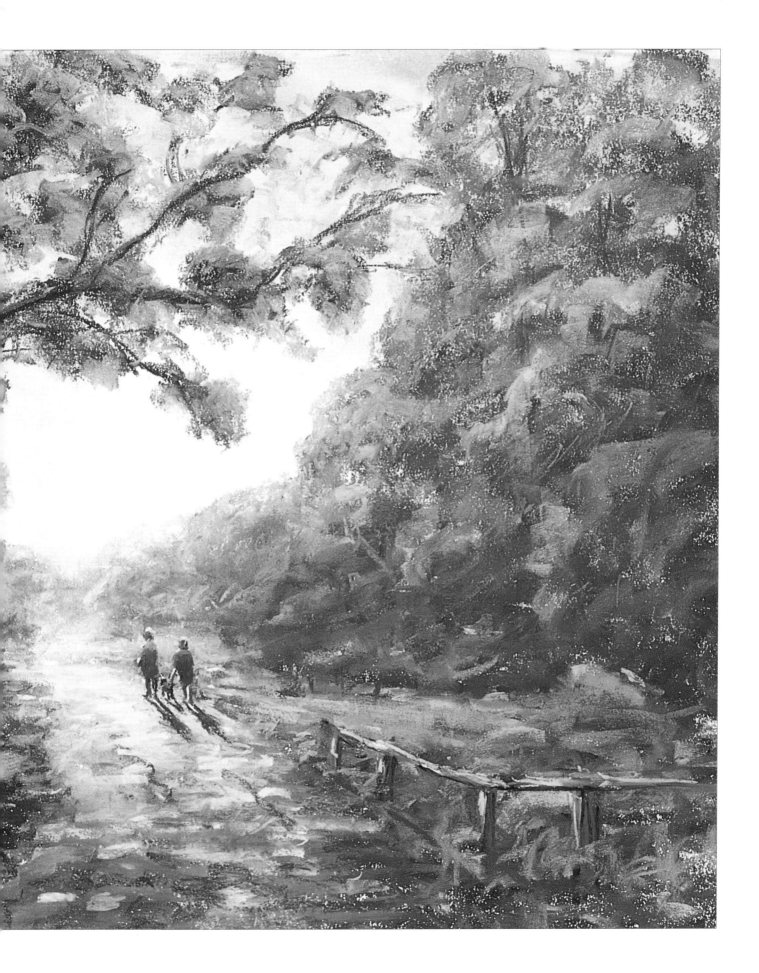

Pastel painting basics

Creating tone

Having made your marks on the paper the fun really begins, and you will soon realize how easy it is to move colour around. Here I show you how to use simple strokes and finger blending to create a beautiful sky. These simple techniques are used for all the paintings shown in this section.

Blending a simple sky

For this exercise, I used two blues and two yellows. The pale blue is Winsor blue (red shade) T1 (tint 1) and the slightly stronger one is cobalt blue hue T2. The yellows are yellow ochre T1 and gold ochre T1. Place the colours randomly over the surface of the paper and then blend them together with your finger to create shape.

1. Use the flat side of the pale blue pastel to lightly apply broad squiggles of colour to the paper.

2. Lay in a deeper tone of blue using the same stroke, but with slightly more pressure.

3. Now work the remaining white areas (the clouds) with a layer of the pale yellow pastel.

4. Then, using very light strokes with the side of the pastel, add a glaze of dark yellow over the other colours.

5. Randomly rub over the colours with a clean finger to smooth and blend them into each other. Work from the centre of the image out towards the edges. Your fingers will get dirty quite quickly, so use wet wipes, a damp rag or some plastic adhesive to clean them regularly.

Colour blending

Although pastel colours are dry, you can create tonal variations by applying colour over colour and then blending them together with your finger. Experiment with colours of your choice and you will soon get the feeling that you are painting, not drawing. Cut across the mixes with a contrasting colour and note how the soft pastel releases pure colour without scraping off the undertones. Here are a few examples of blended colours.

French ultramarine T5, cobalt blue hue T5, Winsor blue (red shade) T4, cobalt blue hue T2 and Winsor blue (red shade) T1

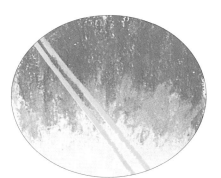

Winsor turquoise T3, Winsor turquoise T1, French ultramarine T1 and titanium white

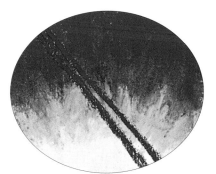

Quinacridone violet T3, caput mortuum T5, burnt sienna T4, Winsor orange T2, raw sienna T2 and yellow ochre T1

Winsor violet T5, French ultramarine T5, ivory black, Winsor turquoise T3, cobalt blue hue T2 and Payne's gray T5

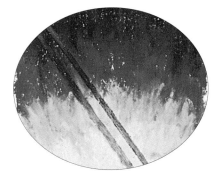

Raw umber T5, burnt umber T4, burnt sienna T4, Winsor orange T2 and raw umber T1

Permanent alizarin crimson T4, Winsor red T3, permanent rose T2 and titanium white

Burnt sienna T4, Winsor orange T4, Winsor red T3, Winsor orange T2 and yellow ochre T1

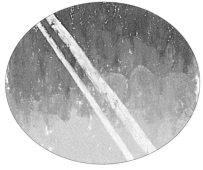

Hooker's green T5, oxide of chromium T4 and permanent green light T5, T4 and T2

Winsor yellow T3, Winsor orange T2, raw sienna T2, yellow ochre T1 and olive green T2

Viewpoint

Your view of a scene determines the position of the horizon line. This must always be at your eye level and horizontal to the bottom of the paper. Whether you are standing on flat ground or on top of a hill looking down on a scene, the horizon line will always be level with your eye. You can place the horizon line anywhere on the paper but, generally, an off-centre horizon will improve a composition. The one-third rule works for most subjects – set the horizon one-third up or down from the bottom or top of the paper.

A view from ground level where the eye level (horizon) is one-third up from the bottom.

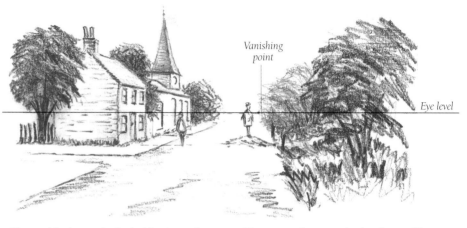

The top of the door on the first building is just above eye level (horizon). The eye level of the adjacent figure is also on the horizon and his scale matches that of the door.

The man standing on a pile of earth is roughly the same size as the other figure, so his head is above the horizon.

Two views of the same scene from different viewpoints.

View from a high level, where the horizon is one-third down from the top.

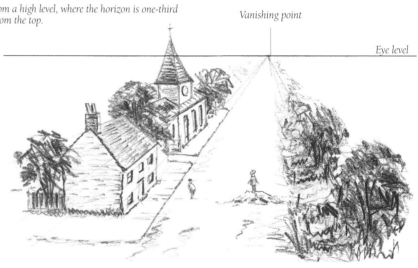

In this view, your eye level is well above that of the figures in the road. The horizon has no influence on the size of the figures, other than to determine their scale relative to the buildings.

A downhill scene can be a very effective subject. Here, the horizon line aligns with the top handrail on the steps of the house on the left. Although the road goes downhill, all the houses are horizontal, so their roof lines should all meet on the horizon.

14

Linear perspective

The relationship between the horizon level and viewpoint determines linear perspective and scale. There are whole books dealing with perspective, so I will not go into too much detail here. However, there are a few basic rules it is important to understand: objects of similar size must appear smaller the further away they are; buildings must stand upright and not seem to topple over; parallel lines, such as wall and roof lines must converge to a vanishing point. Normally, vanishing points will be on the horizon, but there are exceptions. I have included a couple of sketches to illustrate these basic techniques.

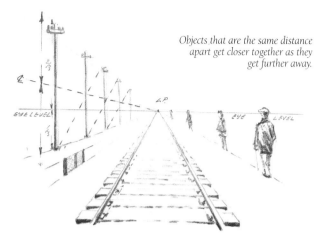

Objects that are the same distance apart get closer together as they get further away.

Lines that are parallel to the horizon remain parallel, and lines that are at right-angles to it converge to a single point on the horizon.

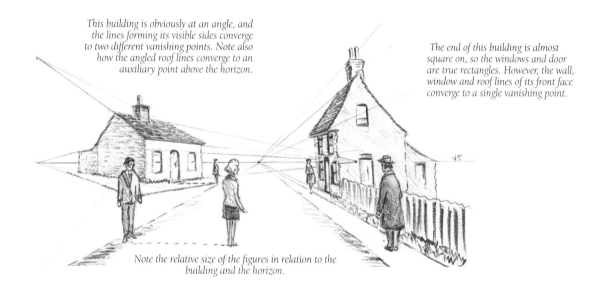

This building is obviously at an angle, and the lines forming its visible sides converge to two different vanishing points. Note also how the angled roof lines converge to an auxiliary point above the horizon.

The end of this building is almost square on, so the windows and door are true rectangles. However, the wall, window and roof lines of its front face converge to a single vanishing point.

Note the relative size of the figures in relation to the building and the horizon.

Form and tonal values

The position of an object in a painting affects the amount of detail (form) needed. Foreground objects need lots of detail to make them realistic. More distant ones are naturally smaller and require much less work to depict them. By varying size and form you create depth, and depth is the essence of good three-dimensional images.

The illusion of depth can also be enhanced by varying the tonal values of colour. Overlay distant objects with cool, pale tints of colour and then, as you work forward, gradually introduce darker tints of warmer colours.

Light source

The position and strength of the light source can dramatically affect the composition and mood of a painting. A high, bright sun produces short, dark shadows, whereas a low setting sun creates long, less dense ones. If you introduce clouds, shadows all but disappear.

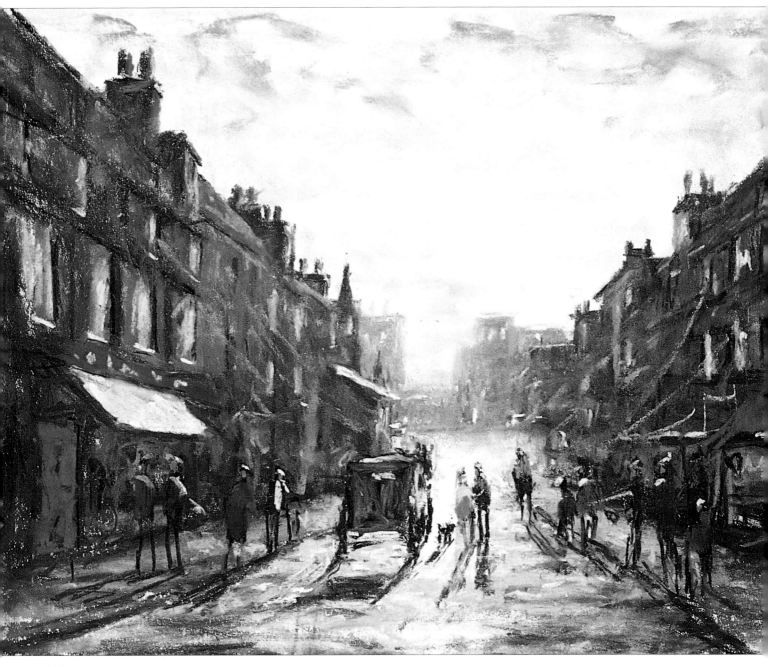

City street
51 x 40.5cm (20 x 16in)

This busy scene combines the techniques of scale, perspective, form and tone to create a good three-dimensional painting. In terms of scale, all adult figures are roughly the same height but note how they become visually smaller as they move further away. The horizon, about one-third up from the bottom of the picture, represents the eye level of both the viewer and the figures in the painting. The slightly off-centre vanishing point for the buildings is accentuated by the angles of the pavements and roof lines. As the windows get further away, they get narrower and closer together, and less form is required to define the structures. In the background, simple blocking suggests distant buildings, and the cool glaze over them contrasts well with the strong brighter tones of the foreground.

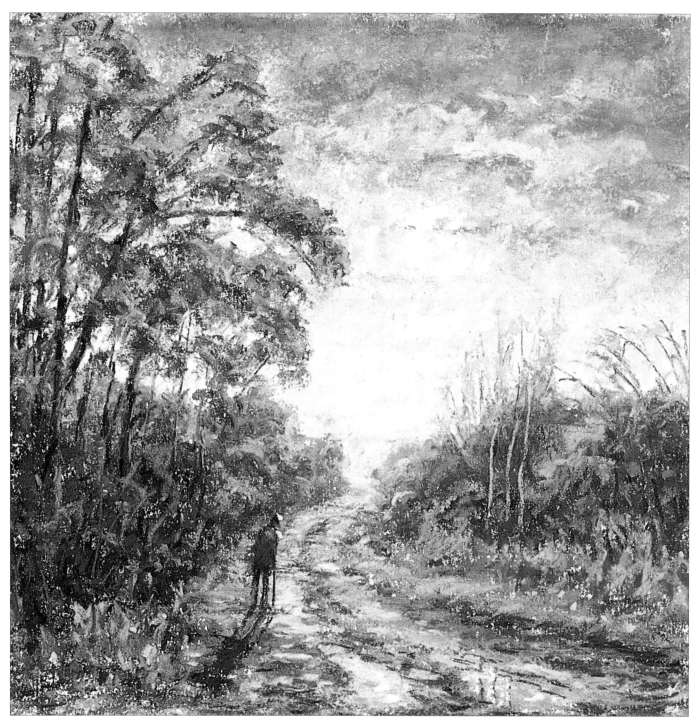

Puddles
20.5 x 20.5cm (8 x 8in)

The low angle of the evening sun creates interesting colours in the sky (which are reflected in the foreground puddles) and long, angled shadows. Note how this back lighting produces highlights on the head and shoulders of the figure.

Using a limited palette

Landing the Catch

You do not need a wide range of colours to create a painting, and here I show you how effective a limited palette can be. Working with just a few colours will develop your sense of tone.

This seascape shows a fisherman returning with his catch after a night's fishing. The subdued colours of early morning combine with the stormy clouds to make this an excellent subject for a limited palette. For this demonstration I used an A4 (8¼ x 11¾in) sheet of 220gsm white pastel paper and six pastels – black and white, and four tints. Black is used as an underlay for the dark areas, whilst white is used to vary the strength of colour created by the pastel tints, and to create highlights.

A pencil sketch of the subject will help determine the tonal strengths required. Start with a few lines to indicate the main shapes and their vanishing points, and then add light and dark tones to reflect the direction of the light source.

Pastels
Ivory black
Titanium white
Burnt umber T5
Raw umber T5
Payne's gray T3
Winsor red T5

1. Outline the picture area, mark the light source and draw in a horizon line approximately one third up from the bottom. Use the side of the titanium white pastel and broad, light strokes to coat the whole surface of the paper.

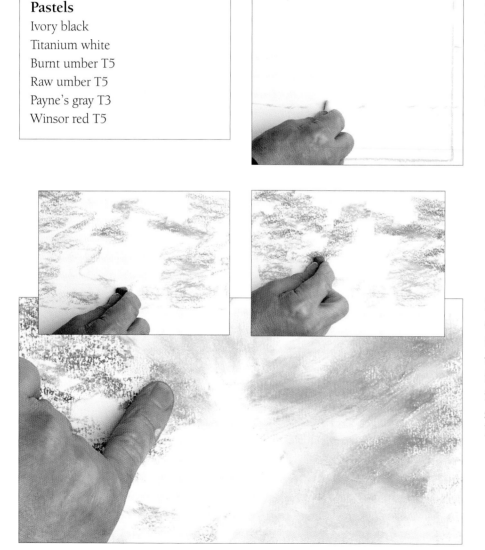

2. Lay in squiggles of burnt umber over the sky, leaving an area for the light source. Overlay these with Payne's gray, then use a clean finger to blend the two colours into each other – work the finger strokes outwards from the central light source.

3. Use Payne's gray and light strokes to shade in the shape of the distant hills.

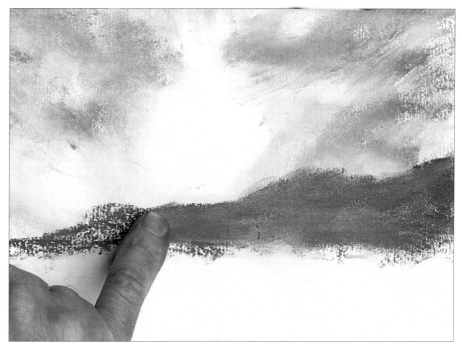

4. Overlay the gray with burnt umber, then fingerblend the colours together.

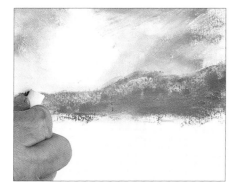

5. Still working lightly, so as not to overwork the colours, use titanium white to lay in highlights on the top of the hills. Blend these into the base colours, following the contours of the hills.

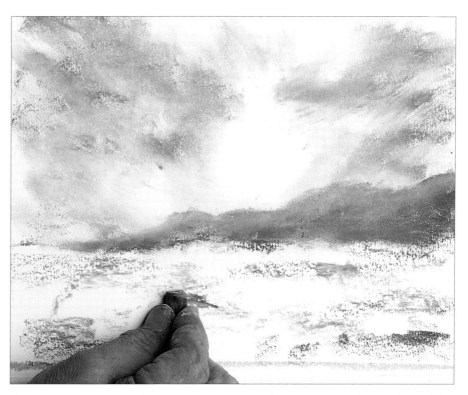

6. Now use burnt umber and more light strokes to suggest the surface of the sea. Leave some areas white to reflect the sky. Work slightly heavier strokes (and hence deeper tones) into the foreground area. Blend the brown into the titanium white base coat, pushing some of the colour back to make weaker tones in the middle distance.

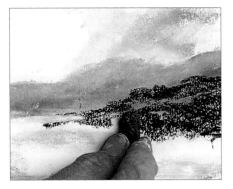

7. Work the basic shape of the middle distance headland using broad strokes of ivory black.

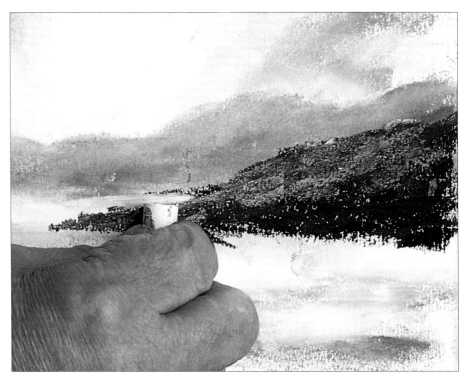

8. Lay a coat of Payne's gray over the black, then a layer of burnt umber. Use the tip of the pastel to add titanium white highlights along the top of the headland.

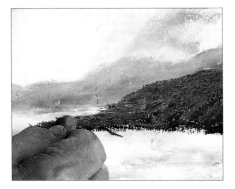

9. Create shape and form on the headland by gently rubbing a Payne's gray pastel over the whole area to blend all the colours together. Use a variety of strokes and lift the back end of the pastel to make small marks.

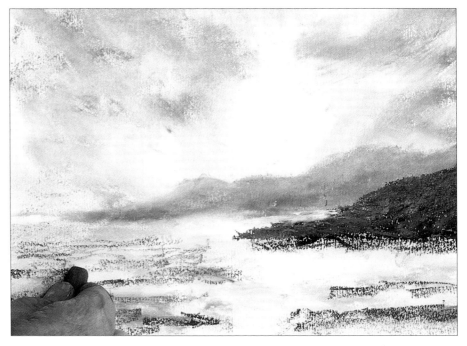

10. Now start to work texture into the sea using raw umber. Apply heavy dark strokes of colour in the foreground, then gradually work back into the distance with lighter, softer touches of colour.

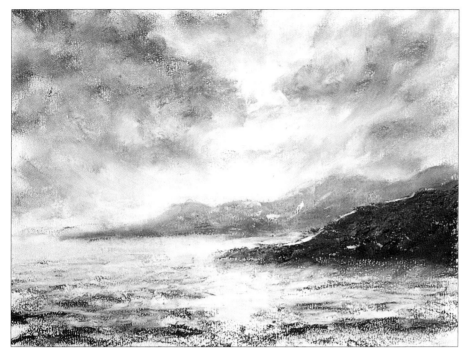

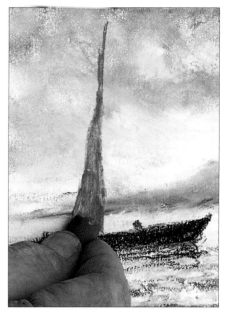

11. Continue to work up the sea and sky, remembering that water reflects the colours in the sky. Use burnt umber to emphasize shadows and the darker foreground areas. Use raw umber and titanium white to create distance and a highlighted area reflecting the light source. Add more burnt umber to the sky to balance the colour of the sea.

12. Use Payne's gray to create the hull of the boat. Overcoat this with ivory black and add the reflections of the hull on the water. Use burnt umber to define the hull and to lay in the mast, sail and the lone sailor.

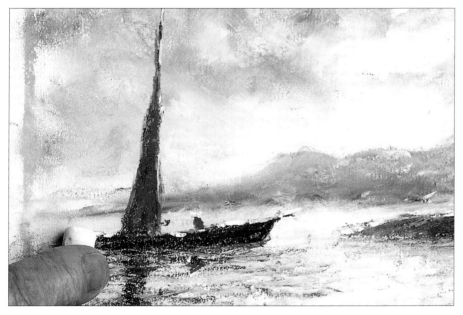

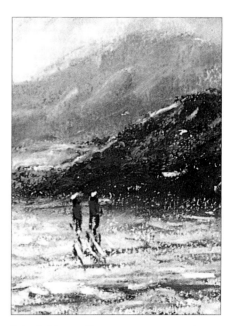

13. Use raw umber and ivory black to add tone to the sail and the reflections of the boat. Add some Winsor red to the sail and its reflection, and a touch to the sailor and his reflection. Add titanium white highlights to the top edges of the boat and its mast and to the sailor's head. Glaze titanium white across the sea.

14. Add two figures to create scale. Use raw umber, overlaid with Winsor red. Highlight their heads with titanium white.

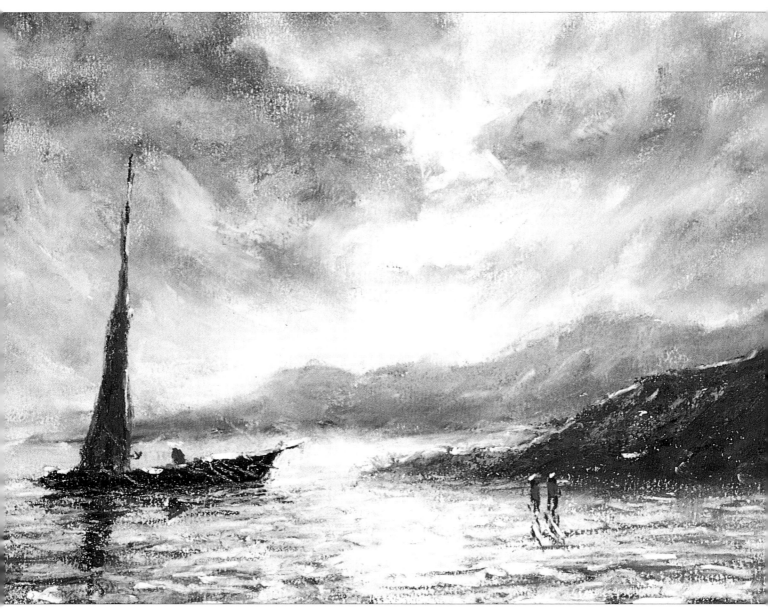

The finished painting

The overhead light is reflected in the dancing waves and the other images in this simple seascape, adding life and a wonderful feeling of movement to the picture.

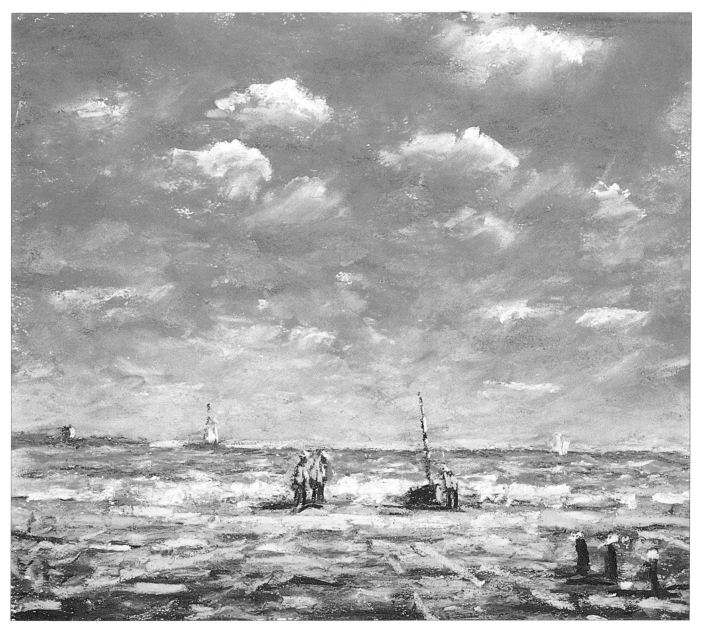

A Walk on the Beach
23 x 20cm (9 x 7¾in)

In this example of a limited palette painting I used six bright colours to create the feeling of a large vista. Compare this to the picture opposite which was painted with more sombre colours.

Painting landscapes

Country Lane

A landscape scene usually has a wide vista with a distant horizon. It should give the illusion of great depth, and scale, perspective, form and tonal values should be used to help achieve this. Although you can create amazing paintings with a limited palette, I generally use a wider range of colours for landscapes – some pale tints to cope with distant tonal values, and stronger tints of brighter colours to bring the foreground closer and to add fine detail.

In this composition, the foreground detail draws you into the focal point, which is the figure walking his dog along the lane. The long shadow of the tree takes you across to the building on the right and its perspective leads you to the distant hills.

I used the smooth side of an A4 (8¼ x 11¾in) sheet of 220gsm pastel paper for this demonstration. Before starting to paint, I outlined the picture area, dotted in the horizon line and marked the source of light.

There is more information on painting landscapes in pages 46–85.

This initial pencil sketch clearly shows the tonal differences between the light and dark areas created by a relatively low light source from the right-hand side of the picture.

Pastels
Cobalt blue hue T1, 2 and 5
Winsor blue (red shade) T1
Winsor yellow T3
Yellow ochre T1
Gold ochre T1
French ultramarine T1 and 5
Payne's gray T3 and 5
Permanent sap green T3
Permanent green light T5
Raw sienna T2 and 3
Oxide of chromium T4
Raw umber T1, 2 and 5
Burnt umber T5
Winsor red T5
Winsor orange T2 and 5
Titanium white
Ivory black

1. Use a mix of cobalt blue hue T2, Winsor blue (red shade) T1, gold ochre T1 and yellow ochre T1 to develop the sky area. Apply the pastel randomly, then gently blend and merge the colours as shown on page 13. Apply French ultramarine T1 to the lower sky. Highlight the clouds with titanium white, blending the colour downwards.

2. Use Payne's gray T3 to block in the distant hills above the horizon, then add depth to them with some Payne's gray T5 followed by a layer of cobalt blue hue T5. Lighten the hill tops with cobalt blue hue T2 – this will make them recede into the distance. Work permanent sap green T3 into the lower hills to suggest foliage. Blend all the colours together then glaze cobalt blue hue T1 across the top of the hills.

3. Define the group of middle-distant trees with raw umber T5. Push cobalt blue hue T5 across the brown to make the trees recede slightly. Apply a touch of permanent green light T5 across the top of the trees, then pull the colour downwards to soften the edges. Blend the colours to create form, then glaze permanent sap green T3 across the trees to suggest highlights in the foliage.

4. Use yellow ochre T1 to colour the surface of the country lane, then block in the remaining white areas with burnt umber T5. Now that all the paper has been covered with colour, the picture takes on a feeling of perspective and realism. Note how the lane leads the eye to the shady woods and on to the distant hills.

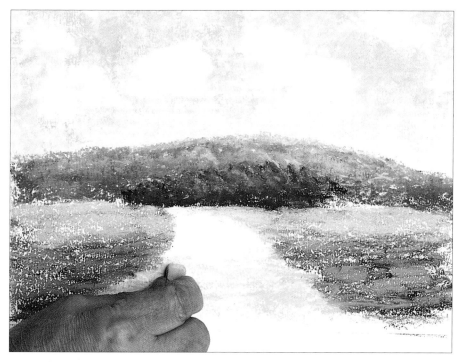

5. Work up the foreground area, gradually increasing the size of stroke and depth of colour as you come forward. Start with permanent sap green T3 and then, as you get closer, use raw umber T5, overlaid with oxide of chromium T4. Emphasize the foreground of the lane with raw sienna T3. Start to merge all the colours together.

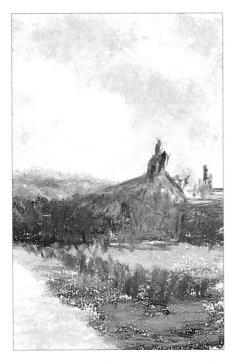

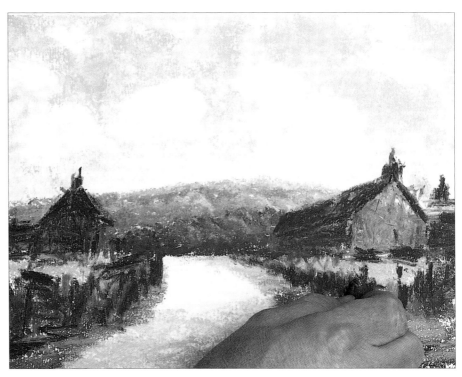

6. Roughly block in the shapes of the buildings, walls and fences using burnt umber T5. Push the pastel into the base colours.

7. Redefine the shapes of the buildings with raw umber T5. Work on the perspective of the roofs, walls and fences. Add shadows as necessary, and allow lighter areas to peep through.

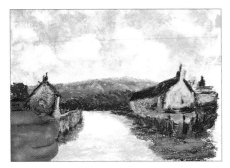

8. Block in the tree behind the left-hand building with Payne's gray T5, and use the same pastel to overlay the right-hand wall. Overpaint the walls of the buildings with raw umber T2. Using the light source as a reference, add reflected light and highlights with raw umber T1.

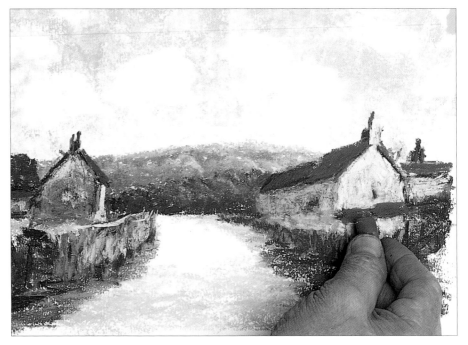

9. Again, bearing in mind where the light is coming from, use Payne's gray T3 to add shadows to the front of the right-hand building and to the end of the left-hand building. Tone these areas down with raw umber T1 and cobalt blue hue T2. Redefine the roofs with Winsor red T5 and then use the same pastel to add detail to the chimney pots.

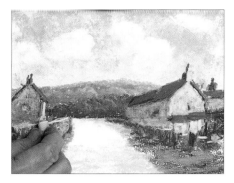

10. Highlight the roofs and chimneys with touches of Winsor orange T5. Use raw sienna T2 to add texture to the end of the right-hand building, to the front of the left-hand building and to the tops of the garden walls.

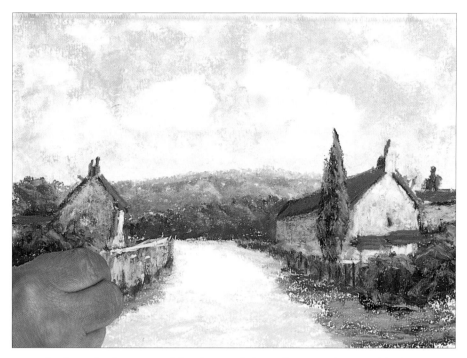

11. Block in the foreground bushes and the tall tree with ivory black. Soften these shapes with raw umber T5, then work texture into them with oxide of chromium T4, allowing some darks to peep through. Glaze permanent green light T5 over the foliage to create texture.

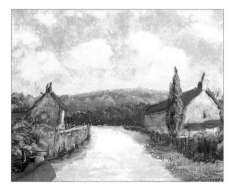

12. Add highlights to the trees, bushes and foreground grass with Winsor yellow T3. Build up shape and form, working the yellow into the other colours. Use raw umber T5 and raw sienna T3 to add the foreground fence. Highlight its top edge with the tip of the pastel.

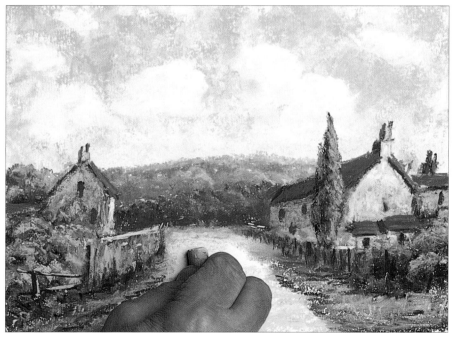

13. Use Payne's gray T3 to paint windows and doors on the buildings, and shadows under the eaves. Apply raw umber T5 over some of the windows and use the same pastel to give form to the edge of the lane. Use French ultramarine T1 at the far end of the lane to create depth. Merge this colour into the middle distant group of trees.

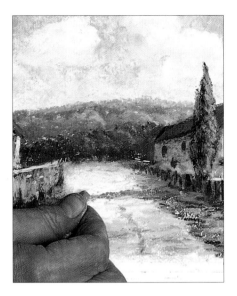

14. Add detail to the lane with raw umber T5 and Winsor orange T5. Blend Winsor orange T2 and yellow ochre T1 into the lane to create a focus of light. Draw in the shadow of the tree using Payne's gray T3 and 5.

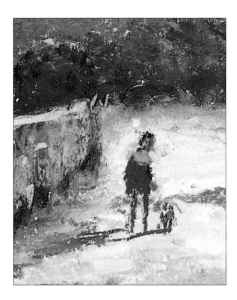

15. Block in the figure and his dog with raw umber T5. Add detail with French ultramarine T5 and Winsor red T5, and highlights with cobalt blue hue T2 and Winsor orange T2.

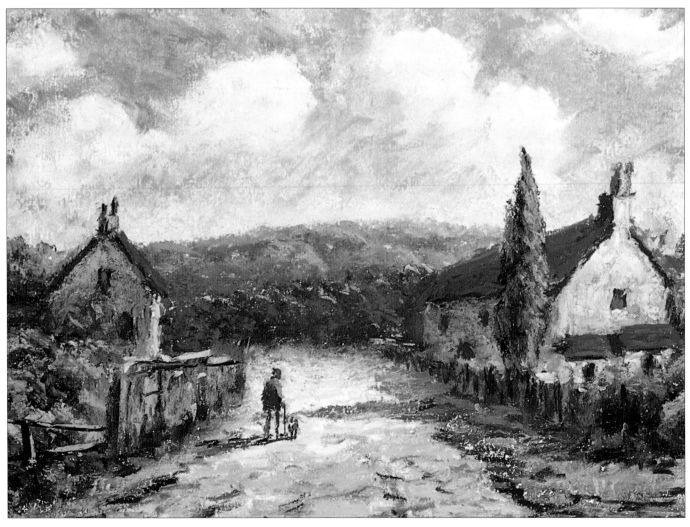

The finished painting

All the shapes and tones have been refined and more highlights have been added. The mixture of greens fading to blue in the distance, and the contrast between the bright foreground colours and the more muted ones in the background add wonderful depth and perspective.

A Walk on the Moors
24 x 16cm (9½ x 6¼in)

In this scene, the opening in the front fence invites you into the foreground paddock. The eye is then drawn to the cottage, out to the two figures and, finally, into the far distance. Note the difference in scale of the cottage to the distant houses at the right-hand side.

Painting water

By the River

Although water is regarded as colourless, it acts like a mirror and reflects the available light and colours. A painted image of water, whether it be sea, river, lake or even a small puddle, must relate to its location and to the influence of the elements such as wind, sun and rain. Smooth water on a lake, for example, creates a mirror image of the background, including the sky. Disturbed water will still reflect background images, but these will be broken with highlights reflected from numerous other parts of the vista.

In this autumnal scene I have tried to capture the movement of river water. The river is quite deep and although the water flows along at a leisurely rate, it is still fast enough to ruffle the surface slightly and distort the reflections. Compare this with the water surfaces featured in other paintings in this section.

The pastels used for this demonstration include a number of warm, rich colours to emphasize the season. The use of bright, violet tints for the flowers on the near bank makes the rest of the painting recede into the background. I painted the picture on an A2 (23½ x 16½in) sheet of 220gsm pastel paper.

The initial pencil sketch. The light source, at the top left of the picture, determines where the light and dark areas should be placed.

Pastels

Winsor yellow, T3 and 4
Winsor red, T5
Indian red, T1 and 2
Winsor blue (red shade) T1
Winsor turquoise T1
Cobalt blue hue T2 and 4
French ultramarine T5
Winsor orange T4 and 5
Payne's gray T3
Raw umber T2, 5
Raw sienna T3
Ivory black
Permanent green light T5
Permanent sap green T3
Hooker's green T5
Quinacridone violet T2, 3 and 5

1. Mark the position of the light source (a late afternoon sun), then use cobalt blue hue T2 to outline the picture area. Place the horizon line one third up from the bottom of the picture, then lightly sketch in the shape of the distant hill.

2. Scribble in the sky using Indian red T2, Winsor orange T5, Winsor turquoise T1, Winsor blue (red shade) T1 and cobalt blue hue T2. Push the colours into each other, then finger blend them together.

3. Add more cobalt blue hue T2, to break up the cloud shapes and reduce their scale. Add Winsor turquoise T1 to the lower left sky area, then Indian red T2. Use the flat side of the pastel to increase the colour, and the tip of the pastel to create highlights. Continue blending the colours to define larger clouds towards the top of the picture. Create perspective in the sky by smoothing out the colours as you work down to the horizon.

4. Block in the distant hills with Payne's gray T3. Then use the flat side of the pastel to scribble raw umber T5 into the wooded area in the middle distance. Define the banks of the river with the same colour and site the end of the far bank with a darker stroke.

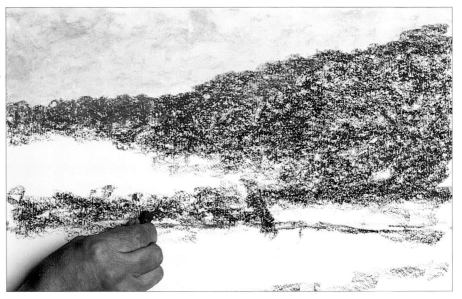

5. Scribble French ultramarine T5 over the Payne's gray on the distant hills and then use it selectively to create deep shadows over the wooded areas that are blocked in with raw umber.

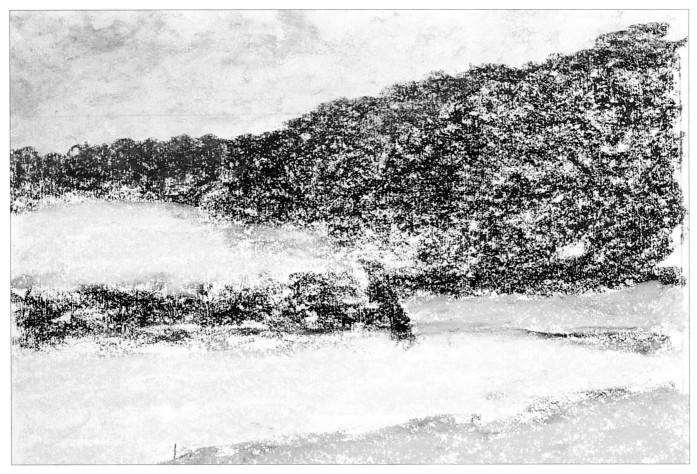

6. Block in the surface of the river and the field on its far bank with Indian red T2. Block in the distant bank and the foreground area with raw sienna T3.

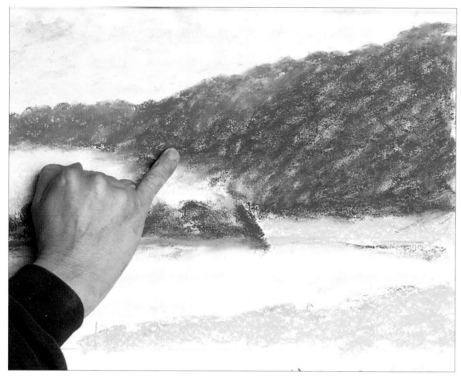

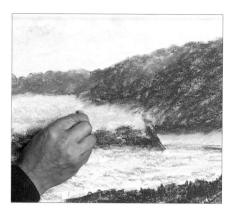

7. Fingerblend the colours in the blocked-in areas, mixing and moving the pigment around to create shape and form.

8. Scribble French ultramarine T5 over the Indian red on the surface of the water and use raw sienna T3 over that on the far bank. Overlay the base colour of the foreground area with ivory black and then add a layer of raw umber T5. Use raw umber T2 to add form to the distant riverbank and to add more colour to the field on the far bank.

9. Start to create depth and perspective in the middle and far distant areas. Work permanent green light T5 into the blocked-in wooded areas, leaving some dark areas exposed – use the flat side of the pastel for soft marks, and its tip for highlights. Apply permanent sap green T3 to the field on the far bank, increasing the tone as you come forward. Add Winsor turquoise T1 to the distant hills and glaze over this with Indian red T2 to add a touch of warmth. Fingerblend the colours, leaving some hard edges.

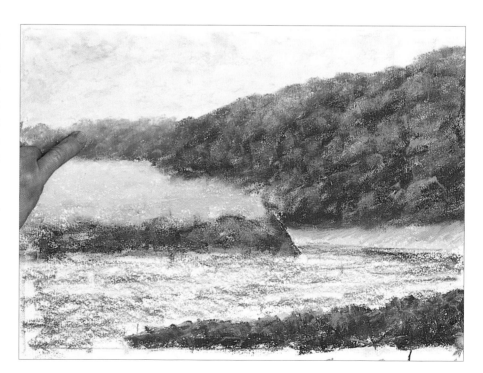

10. Work French ultramarine T5 into the darker areas of the woods to create shadows and texture. Create highlights with Winsor orange T5 and T4, pushing the colours into the greens. Use Winsor yellow T4 to increase the intensity of the highlights on the near trees, softening the edges as you work. Build up the far riverbank with browns and yellows. Continue to build up the trees, working in more colour and blending to define the shapes. Use the same colours to add a little warmth to the near field and the foreground.

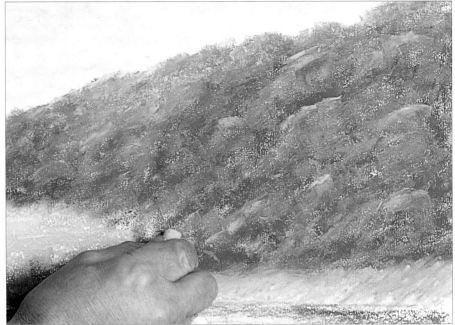

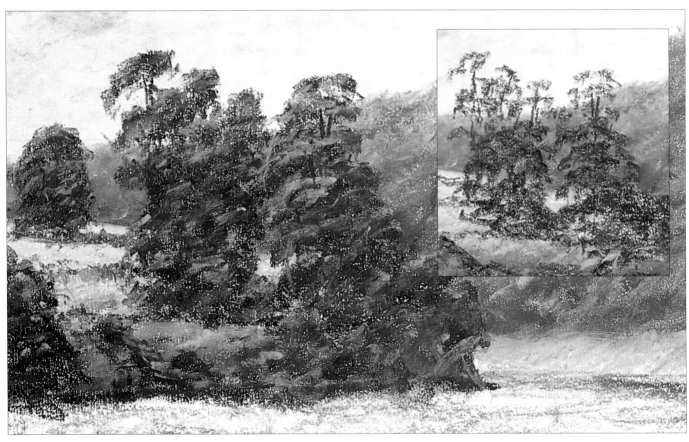

11. Block in the structure of the trees on the far bank with ivory black. Work raw umber T5 into the black areas to tone down the colour and then use permanent green light T5 to start to define the foliage. Glaze cobalt blue hue T4 over the distant tree and shrubbery to push them back into the distance.

12. Now use Winsor red T5 and touches of Winsor orange T5 to add highlights to the tree tops. Add more colour to the centre of the trees to create form. Add small highlighted areas with Winsor yellow T4. Lightly glaze the colour across the far field, dragging the colours into each other. Add highlights of Winsor yellow T3 to the distant trees.

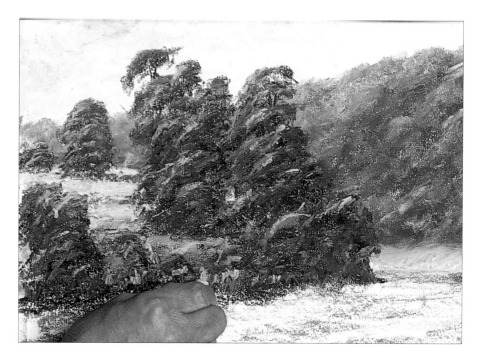

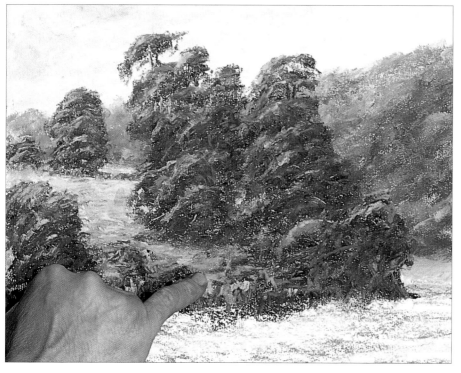

13. Use Hooker's green T5, to define the darker areas on the far bank, softening the black and deep browns. Blend the colour into some of the highlighted areas. Add vertical lines of colour on the riverbank. Use Winsor yellow T4 to blend more highlights over the field and foliage, emphasizing the light and shade. Bring out the lighter foreground areas using permanent green light T5 and T3.

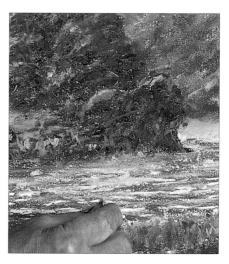

14. Add French ultramarine T5 to work up the colour tones in the water. Apply the pastel with horizontal strokes, following the flow of the water. Glaze Winsor red T5 across the surface of the water to reflect the warmth of the sky. Continue to build up water tones using raw umber T5 in the dark areas and cobalt blue hue T2 and Indian red T1 to reflect the lighter sky colours.

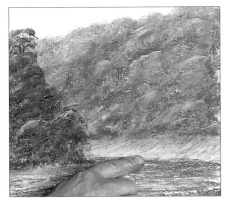

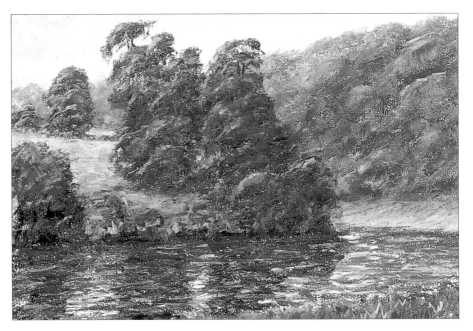

15. Use raw umber T2 and T5 to reduce the brightness of the far riverbank. Add shadows to the upper area beneath the trees, leaving a narrow band of light at the water's edge. Add raw sienna T3 to the lower edge. Glaze French ultramarine T5 over the bank and add subtle shadows to break up the hard line at the water's edge.

16. Add the shadows of the trees across the water using ivory black and raw umber T5. Add reflected lights with Winsor orange T5 then push small areas of French ultramarine T5 into the reflections. Glaze some areas with cobalt blue hue T2 and Indian red T1. Alternate the colours to create movement on the surface of the water.

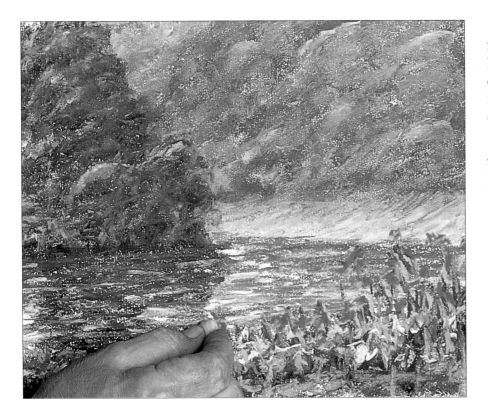

17. Use strong vertical strokes of ivory black, raw umber T5 and Hooker's green T5 to build up colour and texture on the near foreground riverbank. Use a mixture of greens, oranges and yellows to paint in the flower heads and grasses. Add in the wild flower heads using short vertical strokes of quinacridone violet T2, 3 and 5.

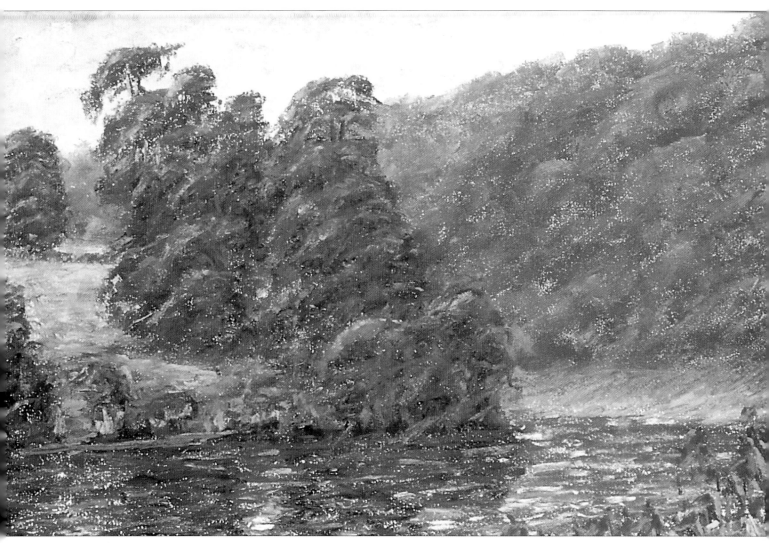

The finished painting
All the colours have been blended further and a focal point (a footpath down to the water's edge) has been added to the far riverbank.

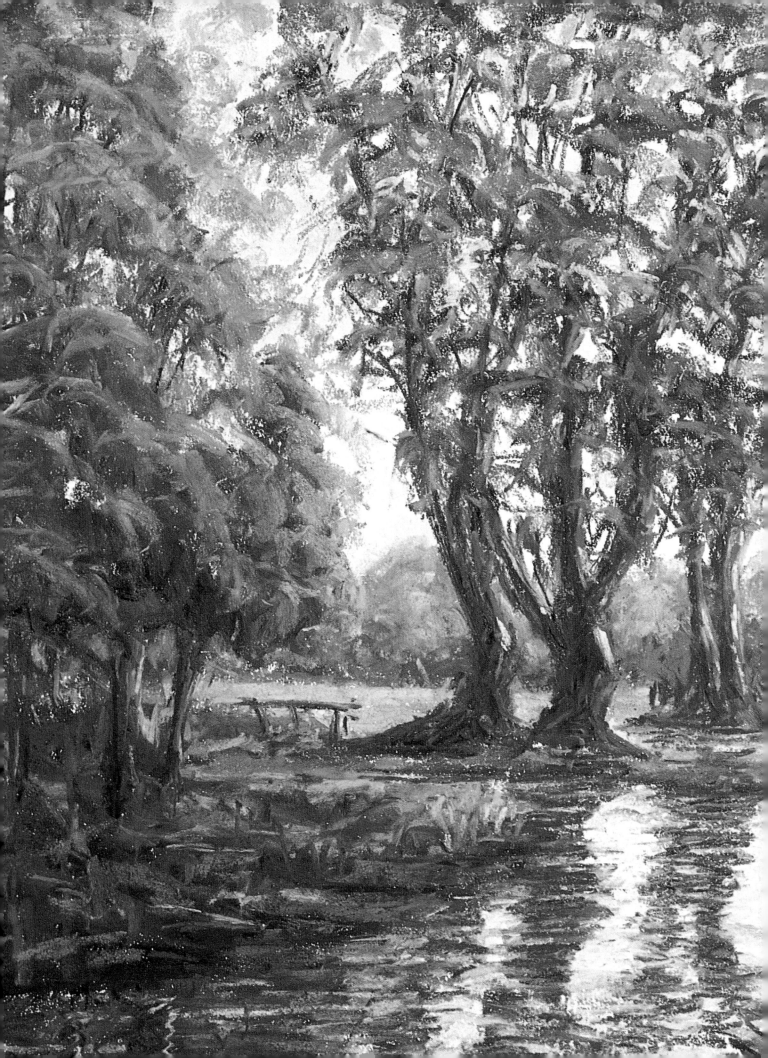

Quiet Reflections
53 x 40.5mm (21 x 16in)

The almost still water in this painting mirrors the shape of the trees in the background. Note that, although the light is coming from the right-hand side, the reflections are at right-angles to the horizon. The colours in the water also reflect the light colouring of the sky and the darker tones of the foliage overhead. Subtle, horizontal strokes of pastel create this quiet water. You need to paint with more verve, using freer strokes, to create a rough, windswept sea.

Creating atmosphere

Moonlit Stroll

All paintings should suggest an atmosphere or mood: compare the dark stormy clouds and sombre tones in the seascape on page 22 with the bright, clear sky and strong warm colours used for the river scene on page 37. These two distinct moods relate to weather conditions, but atmosphere can also suggest action, movement or a particular time of day, as in this demonstration.

For this moonlit street scene, a tinted paper will help to 'get you in the mood' right from the start. Here I use a blue-grey tint of 170gsm pastel paper. The colours used are mostly strong tints of dark colours, but some weak tints that are used to paint the moon are also glazed over the darks to create a diffused luminous effect.

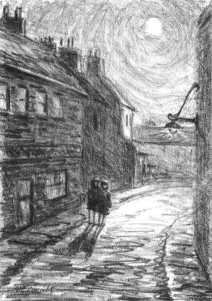

The pencil sketch gives a loose idea of the shapes of the buildings. The position of the moon (the primary light source) determines the placement of highlights and shadows.

Pastels

Cobalt blue hue T4 and 5
Winsor turquoise T1, 3 and 5
French ultramarine T4 and 5
Winsor blue (red shade) T4
Payne's gray T3 and 5
Ivory black
Raw umber T5
Caput mortuum T5
Hooker's green T5
Winsor yellow T3
Winsor orange T3
Quinacridone violet T3 and 5
Titanium white

1. Outline the picture area, draw in the horizon and mark the primary light source. Scribble a base coat of Winsor turquoise T3 over the sky and road areas.

2. Darken the sky with French ultramarine T4 and cobalt blue hue T5, then fingerblend the colours together.

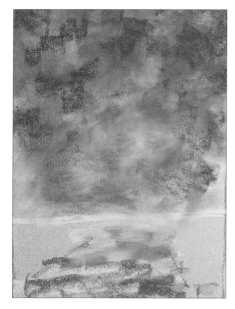

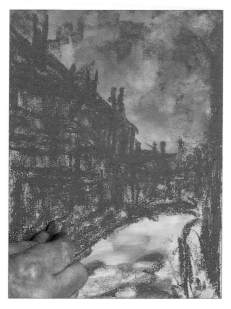

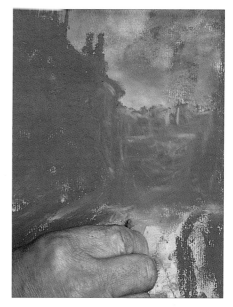

3. Use more French ultramarine T4 to emphasize the dark areas at the top of the sky and to bring the road forward. Lighten the lower part of the sky with Winsor turquoise T3. Blend all colours.

4. Use strong strokes of Payne's gray T5 to block in the buildings and shadows, then merge the pigments to provide a solid undercoat of colour.

5. Push Winsor blue (red shade) T4 and Winsor turquoise T3 into the far buildings to create depth. Add touches of turquoise to the far end of the left-hand building and to the road.

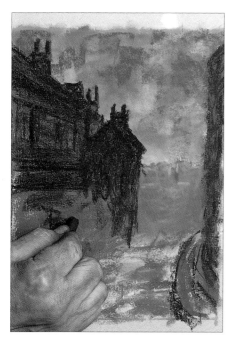

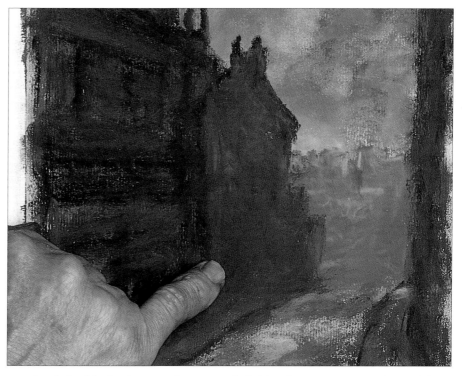

6. Use French ultramarine T4 to overlay the Payne's gray of the left- and right-hand buildings, and to add darks areas in the road. Use ivory black to create shape and structure to the buildings.

7. Blend the black, then push some cobalt blue hue T4 over the far building on the left to suggest reflected light. Work raw umber T5 into the buildings on both sides, and into the pavements and road. Blend the colours to remove hard edges.

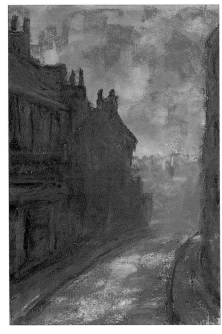

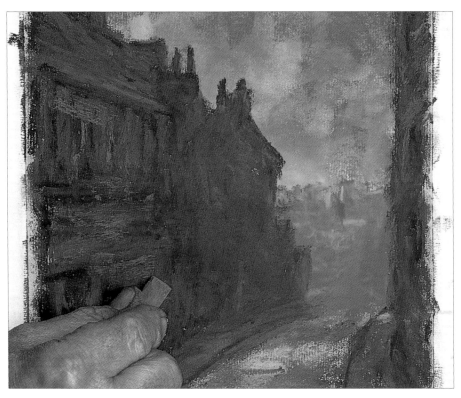

8. Redefine the structure of the foreground buildings using French ultramarine T4 and ivory black. Use French ultramarine T5 to add detail.

9. Use caput mortuum T5 to add light tones to the foreground buildings. Blend these light colours into the dark ones.

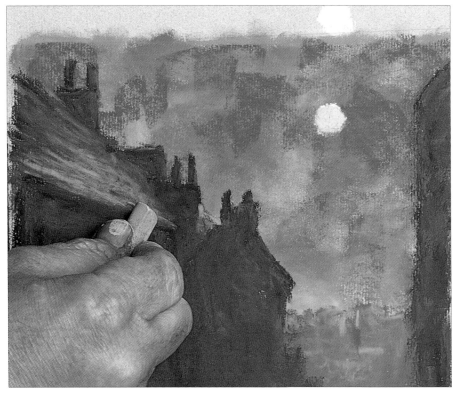

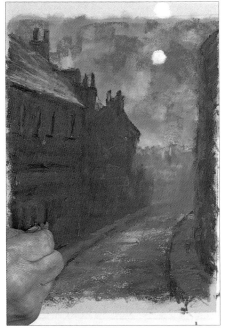

10. Paint in the moon using Winsor turquoise T1, then add reflected light to the roof of the foreground building using T5.

11. Use cobalt blue hue T5, raw umber T5 and Payne's gray T3 to define the architectural detail of the foreground buildings. Push the same colours into the road.

42

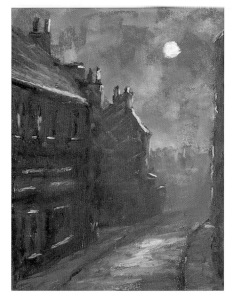

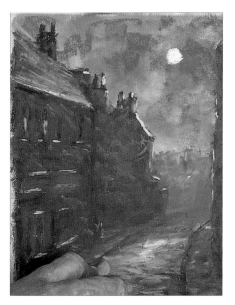

12. Use Winsor turquoise T1 to add highlights to the road, roof edges, chimney pots and windows. Use Winsor turquoise T3 to add more light to the road and to overlay the highlights on the lower windows.

13. Glaze Winsor turquoise T3 over the front of the foreground building to suggest reflected light. Push ivory black into the road and overlay with French ultramarine T5. Redefine highlights with Winsor turquoise T3.

14. Paint the glass windows with Hooker's green T5. Paint a lamp with Winsor yellow T3 and Winsor orange T3 and add reflections on the sill and pavement. Paint the sign with quinacridone violet T5 and T3.

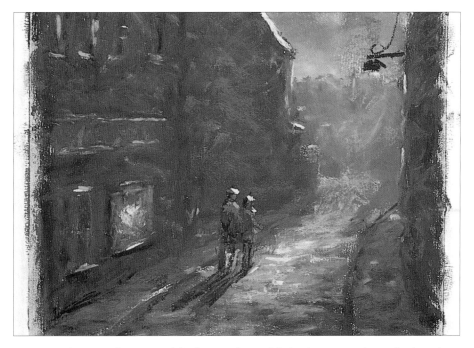

15. Use the tip of an ivory black pastel to add the lamp on the right-hand building, then block in the two figures and their shadows. Use cobalt blue hue T5, raw umber T5 and Hooker's green T5 to colour their clothing, and then ultramarine T4 and a little caput mortuum T5 to define shape. Add highlights of titanium white.

16. Use Winsor yellow T3 to paint the lamp and its reflection on the pavement, and to add indications of illuminated windows in the distant buildings. Use Winsor turquoise T1 to highlight the lamp bracket and to soften the moon.

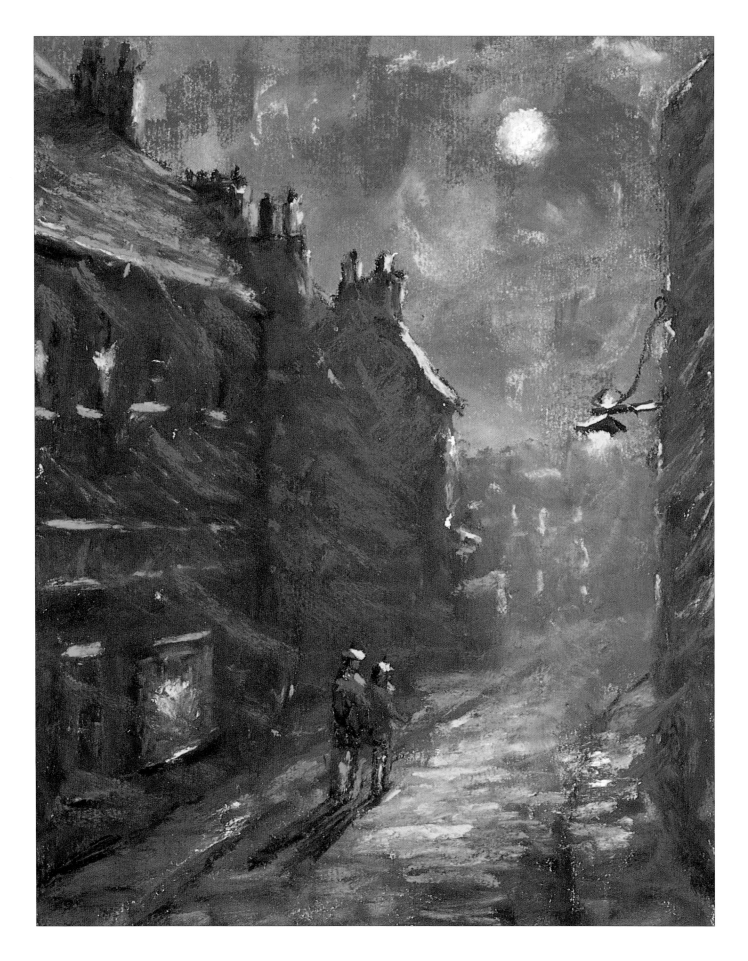

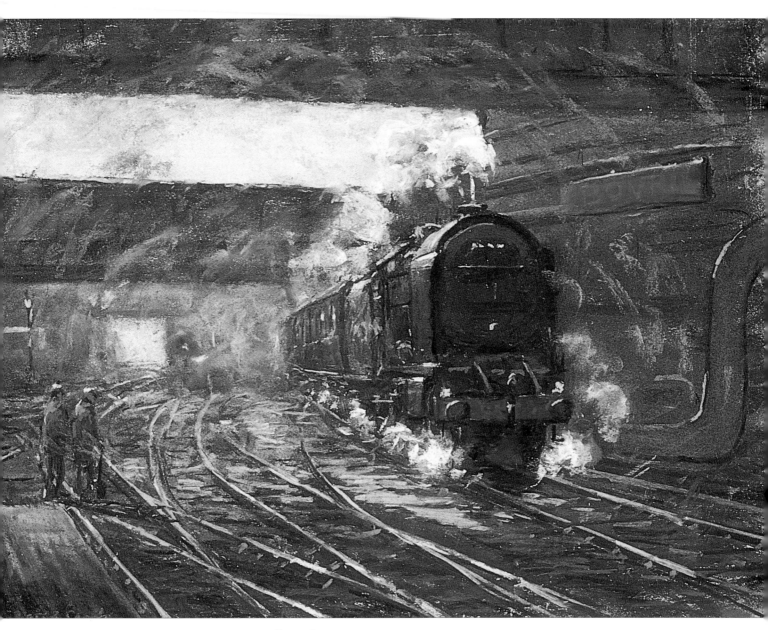

All Fired Up
56 x 40.5cm (22 x 16in)

This scene is full of atmosphere. The locomotive is definitely on the move, pumping steam and smoke into the semi-underground section of track. This movement is accentuated by the stillness of the two figures watching the train go past. Note how the steam and smoke combine to produce a hazy effect over the solid structure of the walls and bridges. Note also how the available light defines the top surfaces of the track and produces a bright area to draw the eye into the painting.

Opposite
The finished painting

More colours have been used to add depth and tone, light and shade. The moon shines down on to the scene, creating both subtle and bold highlights on the figures and buildings. The street lamp and shop window are secondary sources of light that illuminate some areas of the road and throw the adjacent walls into deeper shadow. These contrasts add a touch of drama to the scene. A final glazing of blue across the painting creates a feeling of atmosphere around the two figures as they walk into the distance.

LANDSCAPES IN PASTEL

by Paul Hardy

Pastels are wonderful to work with and they give you a certain thrill right from the first time you use them. They are vibrant, easy to use and have unique qualities: speed and directness of application, and a permanence and vitality that other media lack.

The versatility of pastels is a constant delight – an exciting range of effects can be created, from the soft and subtle tones of an early morning, to the strong and dynamic impression of a stormy landscape. Pleasing results can even be achieved using just one colour and tinted paper. You will soon discover a satisfaction that begs definition when you start using the enormous range of colours that are available, and experimenting with the different paper surfaces.

One of the best teachers for painting the landscape in this medium is the landscape itself. As an artist, you should constantly observe your surroundings. If you do this, you will soon become aware of the composition and colour of things around you, and the play of light and shade on what you see. Your interpretation of these elements will give you great satisfaction, as you apply the pastels and watch your fields, trees and flowers spring to life.

I travel around a lot giving demonstrations, taking workshops and meeting art groups and I frequently hear the comment 'pastels are so messy!' I always reply that such an attitude denies many artists the discovery of one of the greatest pleasures of their painting lives and that they should have a go. I am greatly encouraged by the increasing number of people who are now using pastels, and especially happy about those who take my advice and are 'going to give them a try.'

I want to open up a whole new world and share the endless possibilities of pastels with you. As you read and practise the demonstrations in this book, you will discover the delights and beauty of working with a medium that is both exciting and inspiring. Use your eyes and experiment with colours and techniques – and you will enjoy the challenge of the landscape and the amazing versatility of pastels.

Light and Shade
25.5 x 20.5cm (10 x 8in)

Nature is there to inspire us and should mirror our thoughts. This is a scene that could be complicated, but I simplified it. It has contrast in tonal values and moves from light to dark and dark to light, keeping the eye active discovering different points of view. The buildings are incidental but they do give scale to the whole scene.

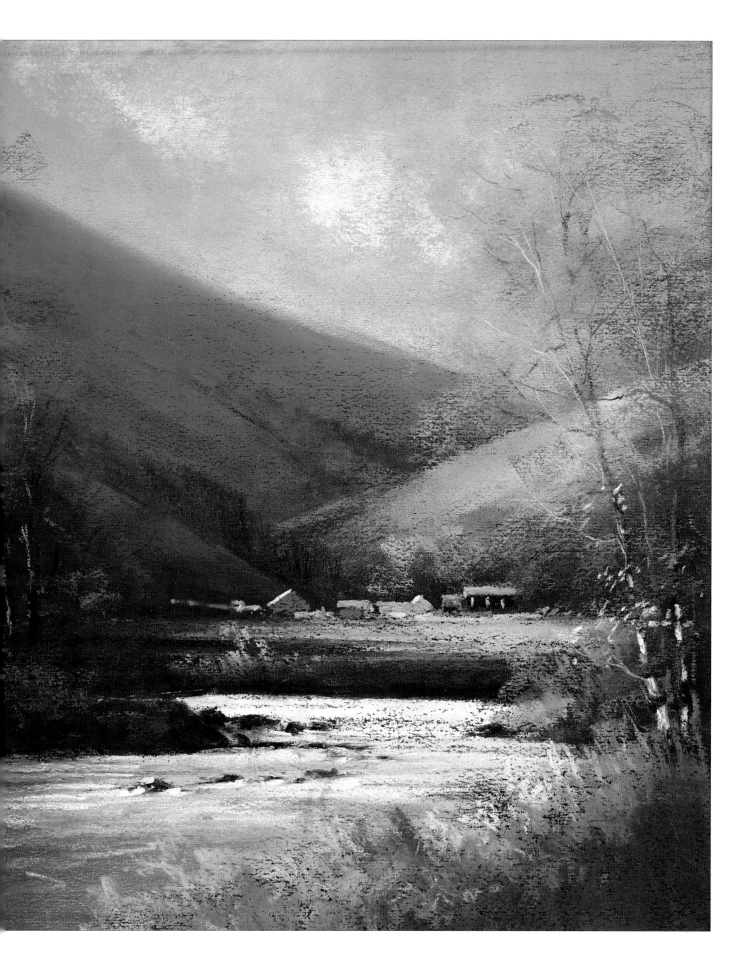

Exploring pastels

The best way to get to know the endless possibilities of pastels is to experiment with these simple exercises. Try making different marks by using the tip and the side of the pastel stick. Lay one colour over another and discover the opacity of pastels. Use your finger to blend the colours together; unlike wet mediums which are blended on a palette, pastels are blended on the paper.

Making marks

The most common way to use pastels is to block in areas of colour using the side of the pastel stick. The amount of pigment released on to the surface will depend on the applied pressure and the surface texture of the paper. These initial marks will invariably leave lots of the underlying colour of the paper visible. You may want to use this effect to advantage, but you can also smooth out the pigments, pushing them down into the surface texture, by rubbing the area with your finger.

Use the side of the pastel to create broad strokes to cover large areas of paper.

Linear strokes, in the form of cross hatching, straight and curved lines and small dots of colour are best worked with the tip of the pastel stick.

Use the tip of the pastel to create fine detail.

Blending

Your paper is your palette; all colour mixing (blending) is performed on the paper. Pastels are quite opaque, so, when you lay one colour over another, the bottom colour becomes hidden. However, when you rub the surface with your finger the pigments of underlying colour merge with those of the top layer to create a blend.

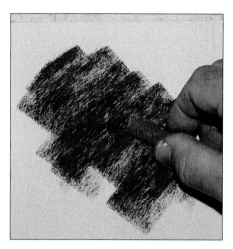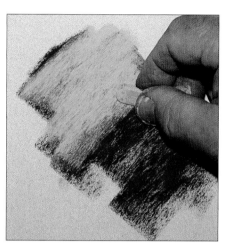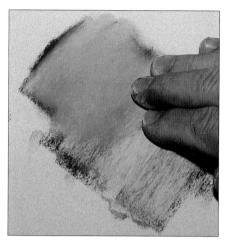

Use the side of, say, a red pastel to cover an area of paper.

Overlay the red with a yellow pastel and note how opaque the colour is.

Use your finger to blend the colours together and create orange tones.

Effects of surface texture

The type of paper you choose to paint on has a great effect on the results of the finished work. The surface texture of the paper can range from quite smooth to very rough and the 'tooth' of the paper affects the way it holds the pastel pigment. The three examples below, of different types of paper, show marks made with the same degree of applied pressure. The right-hand side of each picture shows the initial marks; the left-hand side shows the effect after being blended.

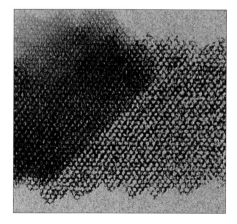

Textured side of pastel paper.

Smooth side of pastel paper.

Abrasive paper.

Composing a painting

Most landscape painters develop their own ideas on how to paint landscapes. Remember that nature does not provide ready-made subjects; our responsibility is not to copy what we see but to create an image that contains nature's component parts. You are interpreting a three-dimensional scene on to a flat, two-dimensional surface. Explore the different elements of a scene and form a personal relationship with them. Adjustments will be made during the process of painting as the eye moves around. On these and the next few pages I discuss the basic elements of composition; there are no hard and fast rules and you will, no doubt, develop your own ideas about what makes a good painting.

Focal point

Landscape compositions should appear to be balanced but not symmetrical. A focal point (centre of interest) should be established before you start painting. This could be an object, such as a building, or an indefinable area to which the eye is drawn. The focal point can be anywhere on the paper but, usually, it is placed slightly off-centre. Compare the two simple sketches opposite.

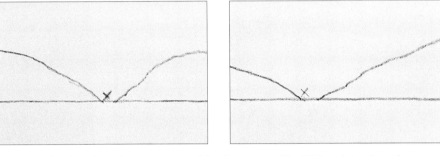

These two sketches show the importance of the focal point. The left-hand sketch, with a centred focal point, is too balanced. Placing the focal point slightly off centre still creates a balanced composition but, although the eye is drawn to that point, it is invited to move around the picture.

Horizon line

The horizon line is always at eye level. However, you can draw the horizon line anywhere on the paper. When I want to paint a dramatic sky against a tranquil landscape I place the horizon quite low down on the paper. Conversely, where the landscape is more interesting than the sky, I place my horizon line in the top half of the painting. Again, never cut the composition into two equal parts by placing the horizon in the middle of the paper.

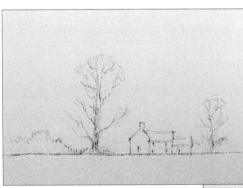

The same scene from the same viewpoint. Although the horizon line is always at your eye level, you can choose to place it low on the paper to create a large area of sky, or high to give you more foreground area to develop.

Skies

Skies are a challenging subject to paint as they never remain still; even the blue of a cloudless sky changes colour every minute.

Use the sky to set the mood of an entire scene, regardless of the other elements of the composition. The sky must always be in harmony with the landscape, be it just a simple background or the principal feature of the painting.

The sky is the main source of light, so be prepared to use a wide range of colours. However, it is not always the palest part of a painting; sometimes it can be the darkest, with threatening clouds covering most of it.

A cloudless blue sky can act as a simple background to a clearly-defined landscape.

Sunshine peeping through breaks in a cloudy sky creates shadows and intensifies the colours in the sunlit areas of the painting.

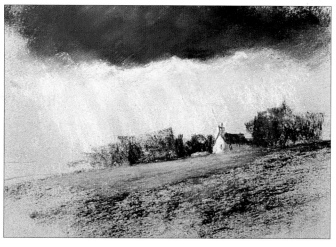

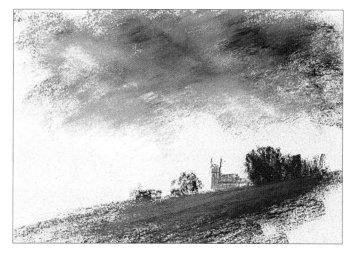

Dark threatening clouds without any hint of sunlight create contrasts in tonal values.

Rain changes the whole atmosphere of a scene and gives us the challenge of painting with muted colours.

Trees

Trees have form and mass, as well as colour, height and width. Before starting to paint deciduous trees, it is a good idea to study them in winter when they are bare of leaves and you can see the skeletal form of the branches and twigs. Make lots of sketches, noting the difference between the shapes of individual trees and those growing close together in woods. When clothed in leaves, trees become a greater challenge. Do not try to recreate each leaf – the patterns of light reflecting off the leaves are more important than leaf texture. Block in the rough shape of the tree, then redefine its outline by painting the 'negative' edge of the sky into the tree. This method gives shapes an accidental quality which is more natural than contrived.

Specimen trees such as this oak and the elm (below) can be the main subject of a landscape painting. Studying their skeletal shapes in winter, when they are bare of leaves, will help you paint them in full leaf.

Groups of trees, such as this stand of pines and the avenue of poplars (below) are often found in the landscape. They may appear regimental in shape, but they are quite irregular and definitely not static.

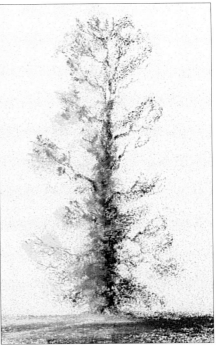

Water

Water has a place in landscapes and it can be used to create a variety of moods. It can be used as the main element in the foreground or as a distant detail. Water has many forms – shallow puddles, fast-running streams, slow-moving deep rivers, waterfalls, snow and ice – so, again, take time to study the different types. Note how water reflects the colours of the sky and the landscape around it. Compare the shapes of reflections in still water with those in moving water. Here, I have included three sketches of very similar scenes but at different times of the year to illustrate some of the many types of water you can come across. I have also included a sketch of a waterfall which has both fast-moving and still areas of water.

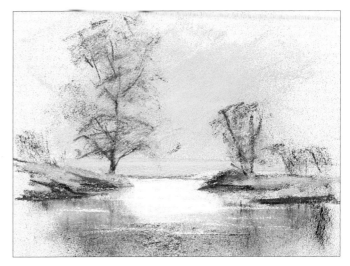

In this scene the river is quite deep, with a flat, mirror-like surface that reflects the images around the water.

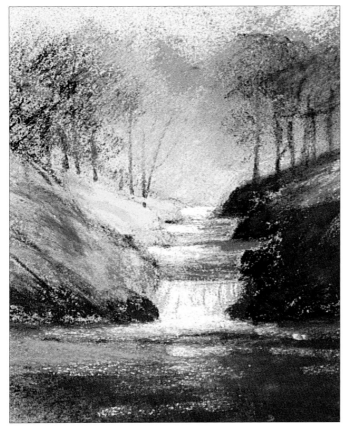

Waterfalls give you the opportunity of combining still and moving water in one painting.

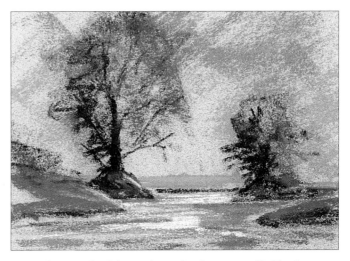

When the water level drops, the surface becomes ruffled by the pebbles on the river bed, causing the reflections to break up.

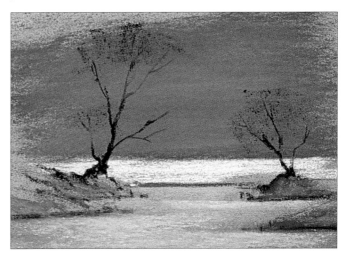

Sometimes, in winter, the river freezes over to form a flat opaque surface that hardly reflects anything at all.

Field sketches

Field sketches are the starting point for painting landscapes and you should endeavour to practise sketching at all times. A sketch book is a means of recording scenes – whole vistas and detailed parts of the landscape – which will prove a useful reference source for many years. Always make notes about the atmospheric conditions prevailing at the time, and mark the direction of the source of light. Never discard such sketches. I usually sketch using soft pencils, charcoal and, of course, pastel but, sometimes, I use watercolours.

When sketching, I view my subject from different places. I look at it from a distance, then move in closer. This observation helps me decide on the composition and design of the final painting. If you have problems with a particular scene, start by sketching in everything you can see. Then turn away and, looking just at your sketch, start to erase things that do not add anything to the composition. Remember that your paintings are not photographs, so you can use artistic licence to add or delete at will.

You can be selective about what parts of a scene you paint, and this allows you to position the horizon line at any point on the paper, although as discussed on page 50, an off-centre horizon works best. I like to have a low horizon when the sky is the most dominant part of the painting, and a high horizon where there is more interest in the foreground.

You should also consider where to place the focal point or centre of interest. Use the lines of nature to help bring the composition together. Again, never place the focal point in the middle of the paper.

On these pages I show you a few sketches of the same scene made from different viewpoints. Each sketch would make a good painting.

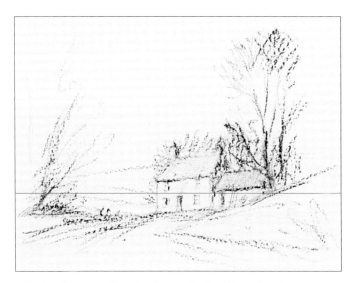

This sketch was made quite close to the buildings. At this point the road is quite flat and the horizon line, shown in red, is in the lower half of the composition, roughly level with the top of the door. The curve in the road leads the eye to the focal point, the buildings, which are placed slightly to the right of centre. The trees on either side provide a frame for the composition and also link the foreground land to the sky.

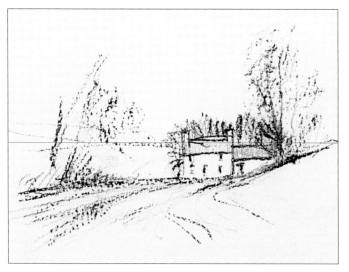

Going back up the road, which is now on a downward gradient, raises the eye level to the roof line of the right-hand building. New hills appear in the distance, and there is more foreground. The basic composition is still quite pleasing, but, as the horizon line virtually cuts the composition in half, I would overcome this by reducing the area of foreground and adding more sky.

I went to the top of the hill to make this sketch. The horizon line, now in the top half of the paper, is virtually level with the distant hills. From this vantage point, I can see down into the valley below the buildings, giving added interest in the middle distance. I chose this sketch as the basis for the pastel painting below.

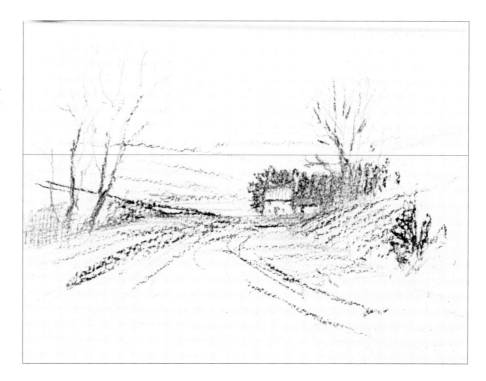

Through the Valley
22 x 15cm (8½ x 6in)

This painting is based on the field sketch above.

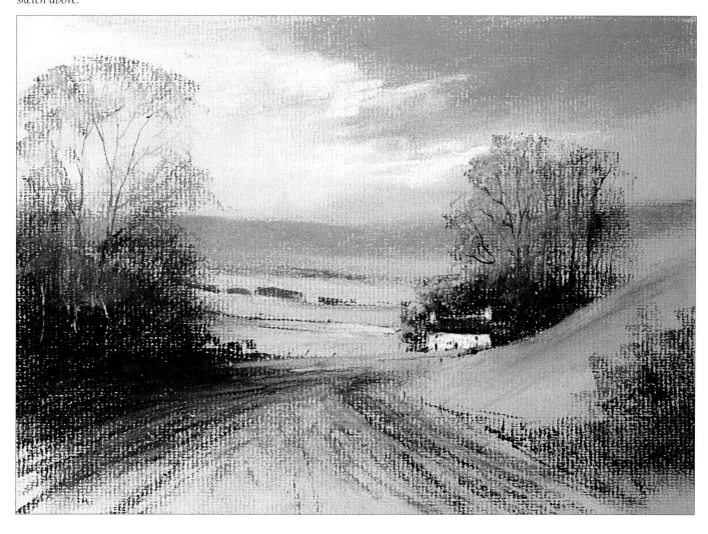

Hills and Vale

For my first demonstration I have chosen a very simple landscape that requires the minimum of drawing. A few guidelines are all that is needed to set the scene. Although this is a landscape, the sky dominates the composition and sets the mood of the painting. The idea is to depict space on a large scale, so there is hardly any detail. There is no definite focal point, just a space below the distant horizon on which the eye settles before exploring the rest of the painting. In the finished painting, I added the indication of a few sheep to help set this point.

I painted this demonstration on a 560 x 380mm (22 x 15in) sheet of 400 grade sandpaper, but I worked within a 420 x 350mm (16½ x 13¾in) aperture.

I based the demonstration painting on this initial tonal sketch which was drawn in charcoal.

Colours

Blue/green	Crimson lake	Sap green
Burnt umber	Earth green	Sepia (pastel pencil)
Cadmium yellow	Grey	Violet
Cerulean blue	Hooker's green	White
Cobalt blue	Olive green	Yellow ochre
Chrome yellow	Prussian blue	
	Purple	

1. Use a sepia pastel pencil to draw a border and the horizon.

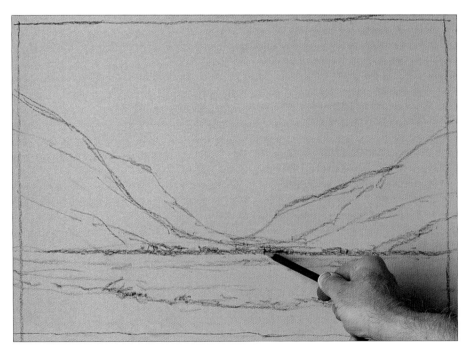

2. Sketch in the outlines of the composition, then mark the focal point (centre of interest).

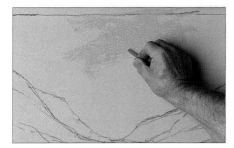

3. Use a mid tone cerulean blue to block in the upper centre area of the sky.

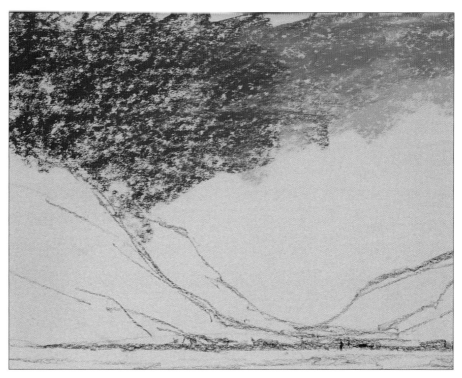

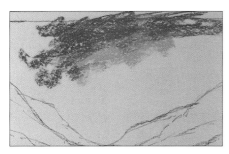

4. Add some cobalt blue over the top part of the sky.

5. Complete the blue part of the sky by blocking in the left-hand side with dark Prussian blue.

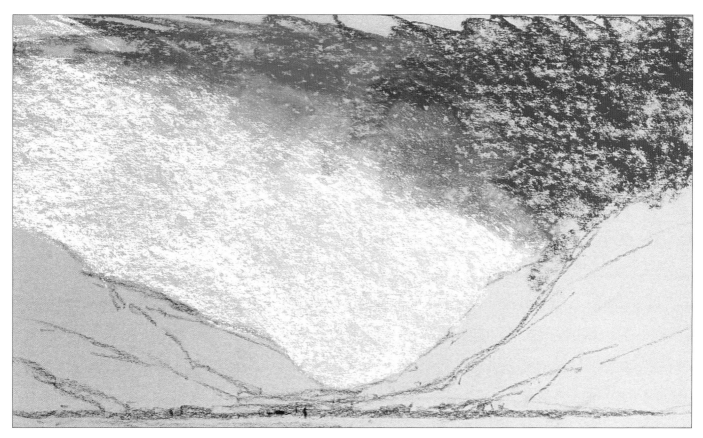

6. Block in the rest of the sky areas with a pale yellow ochre, varying the pressure as you work.

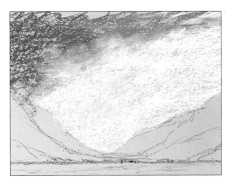

7. Apply a mid tone yellow ochre over the pale yellow area, taking it up into the pale blue sky.

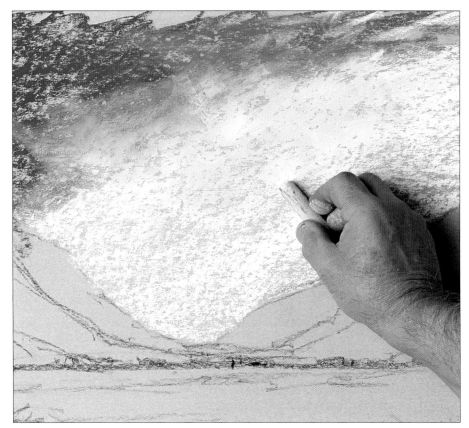

8. Use pale crimson lake to create a warm glow in the centre of the sky.

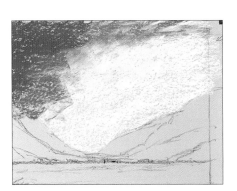

9. Finally, use a mid tone violet to darken the left-hand corner of the sky.

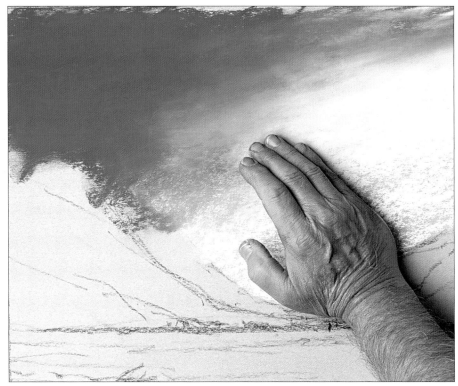

10. Now use long sweeping strokes of the heel of your hand to blend the colours together.

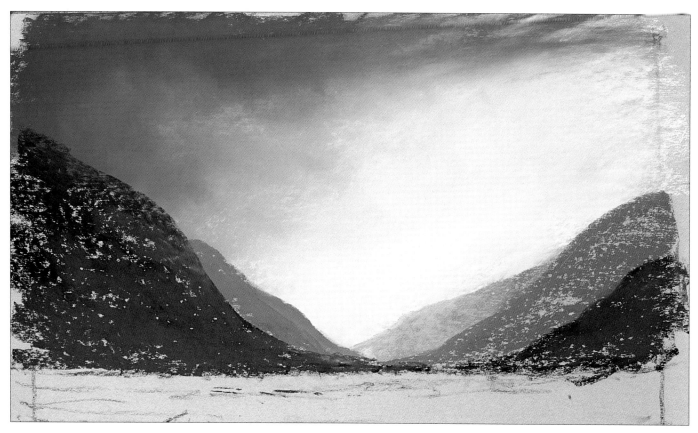

11. Block in the left-hand hills. Use mid violet for the distant hill, mid blue/green for the next nearest, then dark blue/green and Prussian blue for the nearest hill and the marks along the horizon. Working from the most distant, block in the hills at the right-hand side. Use pale violet, mid blue/green, then dark blue/green with touches of very dark blue/green. Soften the nearest hills with touches of mid grey.

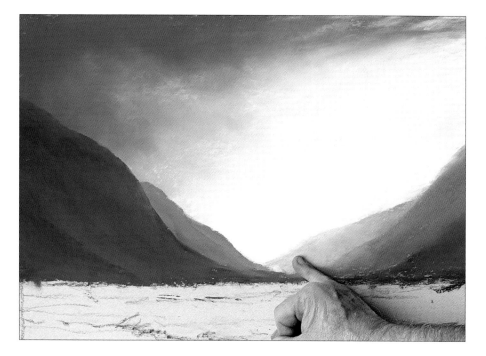

12. Use the heel of your hand and your finger to blend the colours and to develop the contours of each hill.

13. Use tones of burnt umber and olive green to continue developing the background. Apply touches of pale yellow ochre to suggest sunlight on the nearest hills.

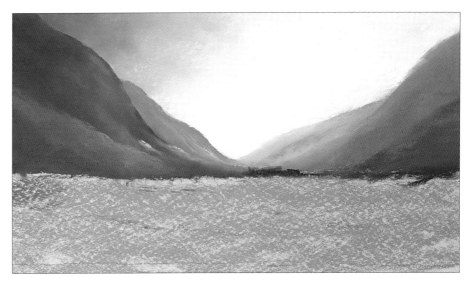

14. Block in the whole of the foreground with sap green.

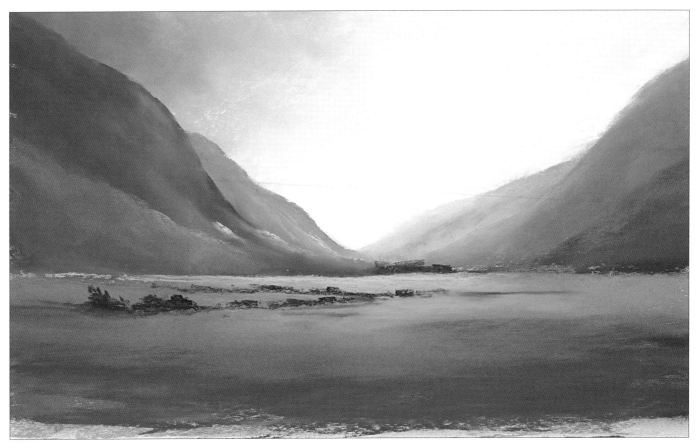

15. Working from the left-hand side, apply Hooker's green, then sap green across the paper. Blend the colours together. Work in dark Hooker's green at the left-hand side and across the bottom of the foreground. Apply chrome yellow against the horizon, adjacent to the focal point. Bring this colour forward, gradually reducing its intensity. Create some bushes in the middle distance with dark Hooker's green, then add a layer of Prussian blue over the grasses in the foreground.

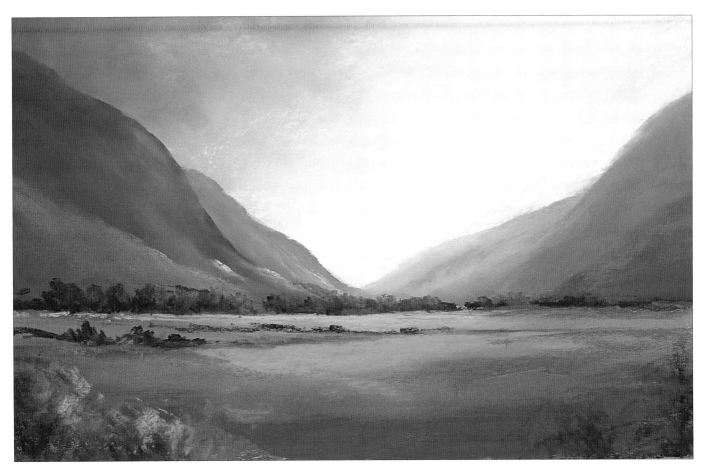

16 Use dark blue/green and very dark purple to work a tree line across the horizon and to add more shape to the middle distant foliage. Add an indication of foliage in the foreground to create a sense of depth. Create highlights with touches of sap green.

17. Use cadmium yellow to create highlights on the distant trees.

18. At this stage I decided that the bushes in the middle distance intruded too much, so I blocked over them with dark earth green.

19. Develop the centre of interest by making a few small marks with a white pastel to indicate a few sheep. At this distance, there is no need to make these marks too detailed.

20. Use the white pastel to block in a few wispy clouds – soften the tops of them with your finger.

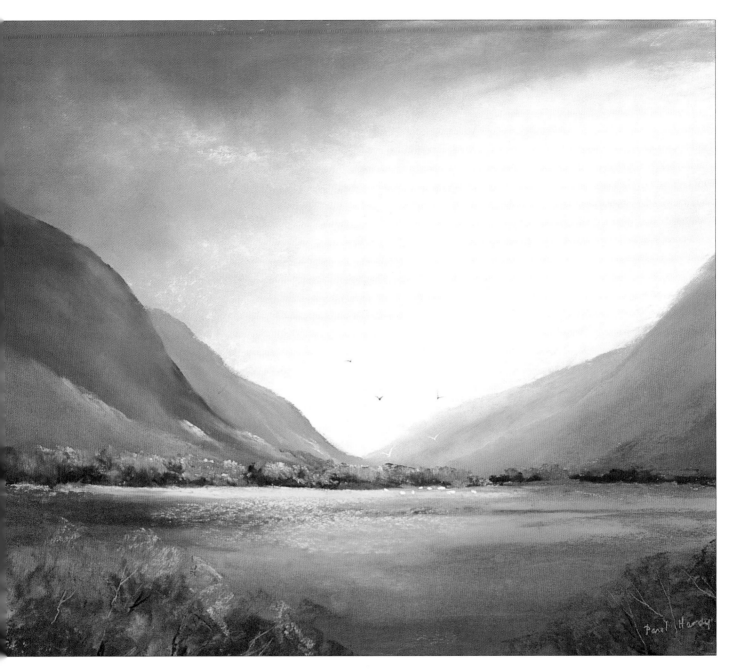

The finished painting
42 x 35cm (16½ x 13¾in)

I added more detail in the foreground, then completed the painting by drawing a few birds in the sky. At this stage, I also decided to crop the painting at the sides to make a more pleasing shape.

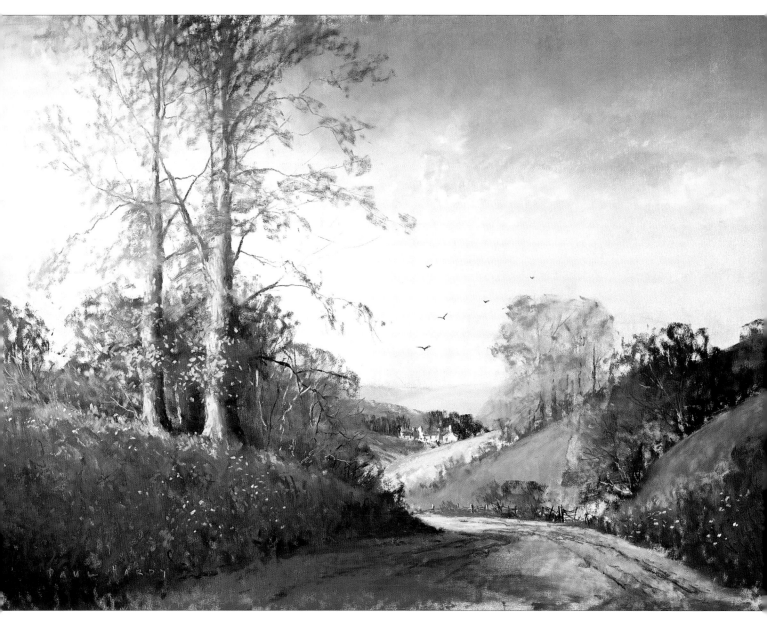

Morning has Broken
51 x 38cm (20 x 15in)

Much of the appeal of landscapes is in the strength of what is being expressed. Here it is the warmth of the sun, the rich colours of late autumn and the deep shadows. The road leads us into the picture; it makes us wonder what is round the corner before taking the eye through to the cottages on the distant hillside.

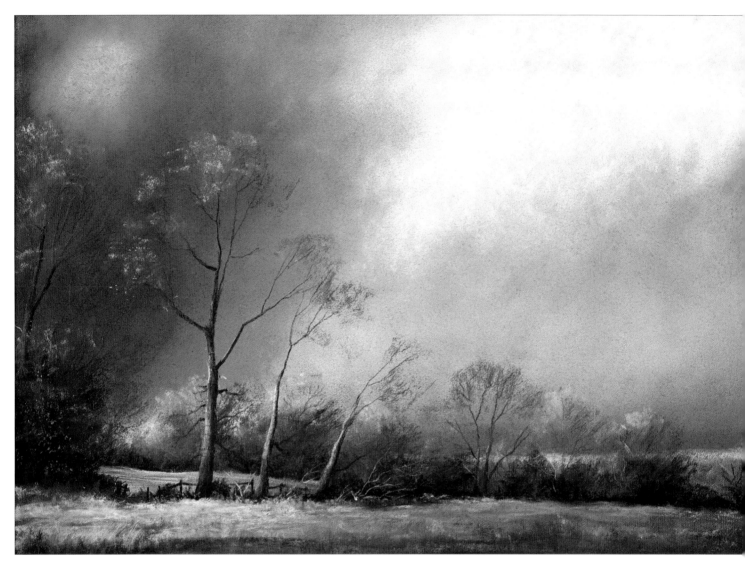

Between the Showers
51 x 38mm (20 x 15in)

When the sky is the dominant feature of a painting, I tend to place my horizon line very low on the paper. Remember that other areas of the painting have to compete with the sky, and I have used a series of trees to link all the elements together. The emotional response to dramatic compositions such as this will be with the viewer. Has a storm just passed by to allow the sun to shine, or is this the sunny interlude before a cloudburst?

Bright Interval
38 x 30.5cm (15 x 12in)

The sky is the backdrop for every landscape and it can be used to create different moods. Here I have painted a dramatic, turbulent dark sky with clouds to contrast the stillness of the landscape. The sunlight in this painting has a luminosity and warmth that emphasises tonal values and colours.

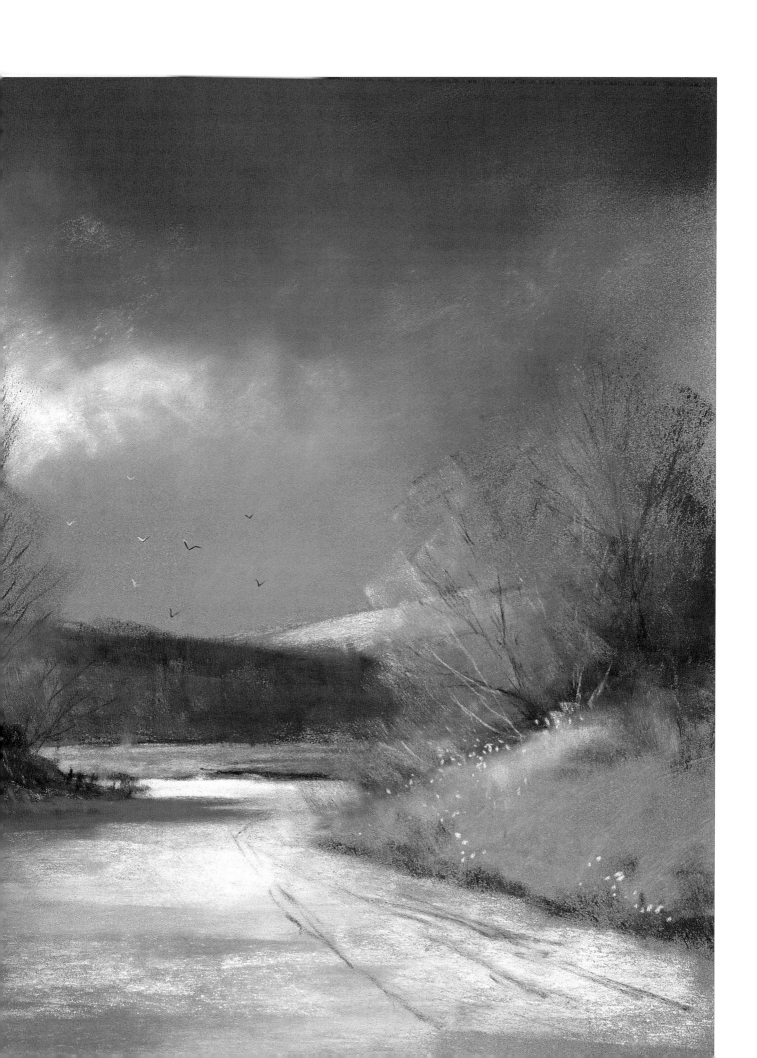

The Old Tree

The landscape contains a whole host of different types of tree, giving us a variety of shapes and forms to choose from. Most landscapes will depict trees *en masse* but, sometimes, a particular tree will inspire you to paint it. This can present quite a challenge to the beginner; the closer you are to the tree, the more definition you must include in the painting. In this demonstration, I show you how I paint a tree portrait.

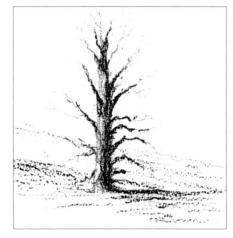

The tree in this demonstration is clothed with leaves, but it was based on this sketch of the bare branches and trunk of the oak. Remember to allow for the light source when drawing tonal sketches.

Colours

Black	Chrome green light	Prussian blue
Blue/grey	Cobalt blue	Raw sienna
Cadmium orange	Emerald green	Sap green
Cadmium yellow	Hooker's green	Yellow ochre
Cerulean blue	Lemon yellow	
Charcoal pencil	Mauve	
Chrome yellow	Olive green	

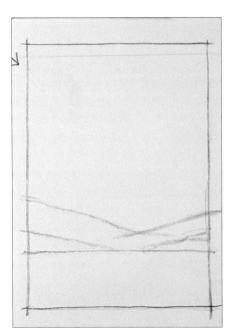

1. Use a charcoal pencil to draw in the border, the horizon, the light source and the outlines for the distant hills.

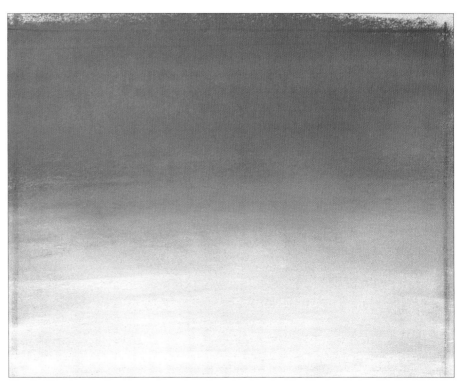

2. Block in the sky with cobalt blue, cerulean blue and a pale yellow ochre, and blend the colours together with the heel of your hand. Add touches of pale mauve to the top of the sky and blend.

68

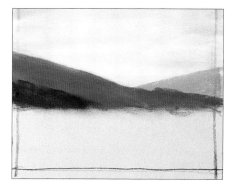

3. Use a pale blue/grey to block in the distant hillside, and mid and dark blue/grey for the near one. Use Prussian blue to suggest a distant group of trees. Overlay the near hillside and the trees with sap green, then use your finger to blend the colours together.

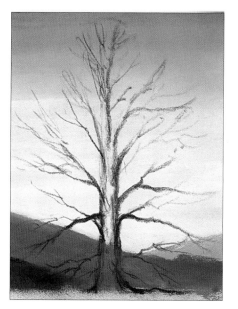

4. Now use a charcoal pencil to sketch in the skeleton of the tree.

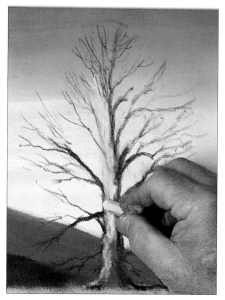

5. Use cadmium yellow to add highlights to the tree trunk and the upper branches.

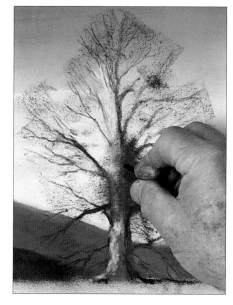

6. Use dark olive green to block in the shadowed parts of the foliage, skating across the surface to leave very pale marks.

7. Use dark olive green to add shadows to the right-hand side of the tree trunk and the major branches – away from the light source – and to the underside of the branches at the left-hand side.

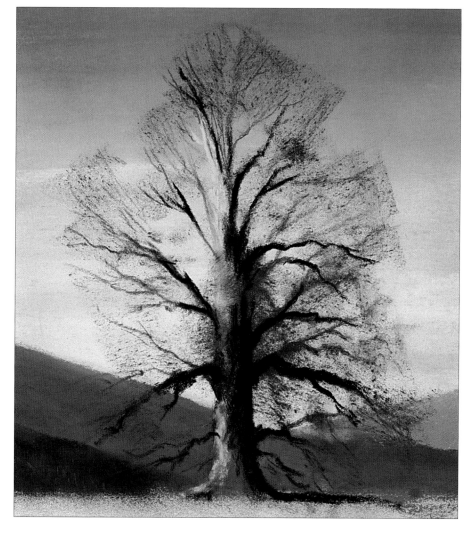

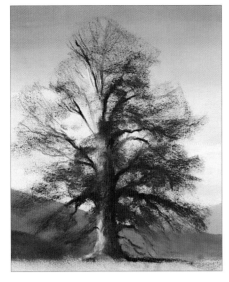

8. Use dark Hooker's green to start to develop the foliage.

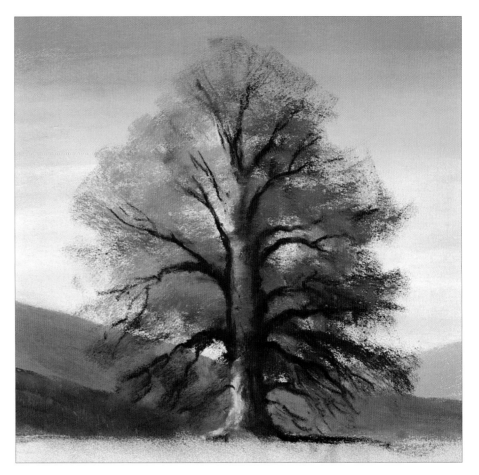

9. Use mid sap green to work up shape and form, then use paler shades on the lit side of the tree. Use black to redefine the trunk and branches, and to emphasize the foliage at the back of the tree.

10. Now use a mid raw sienna to block in the foliage at the front of the tree.

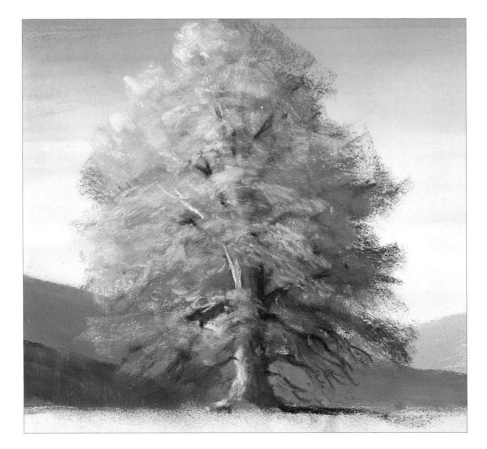

70

11. Continue developing the shapes with pale sap greens and chrome yellows. Reinstate parts of the trunk and branches with black and cadmium yellow. Add touches of mid emerald green and chrome green light to create highlights. Add texture by stippling tiny marks with greens and yellows.

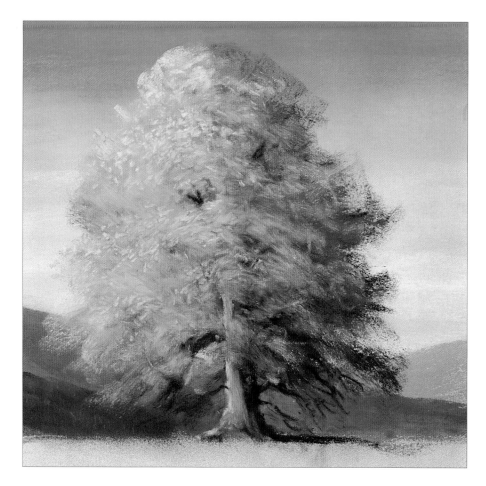

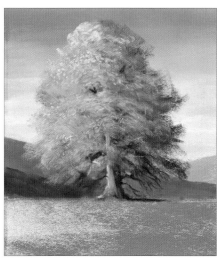

12. Block in the foreground using mid sap green overlaid with pale sap green. Remember that the lightest area is nearest to the light source.

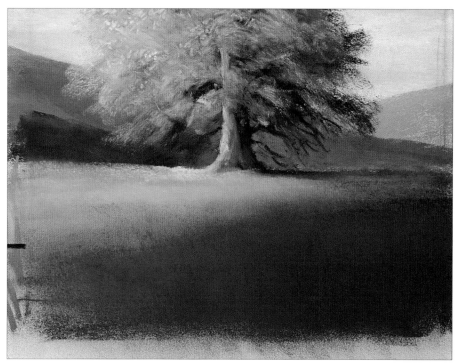

13. Overlay the foreground with Prussian blue and lemon yellow. Blend the colours together. Reinstate the highlights on the tree trunk with cadmium yellow, and the shadows with Prussian blue.

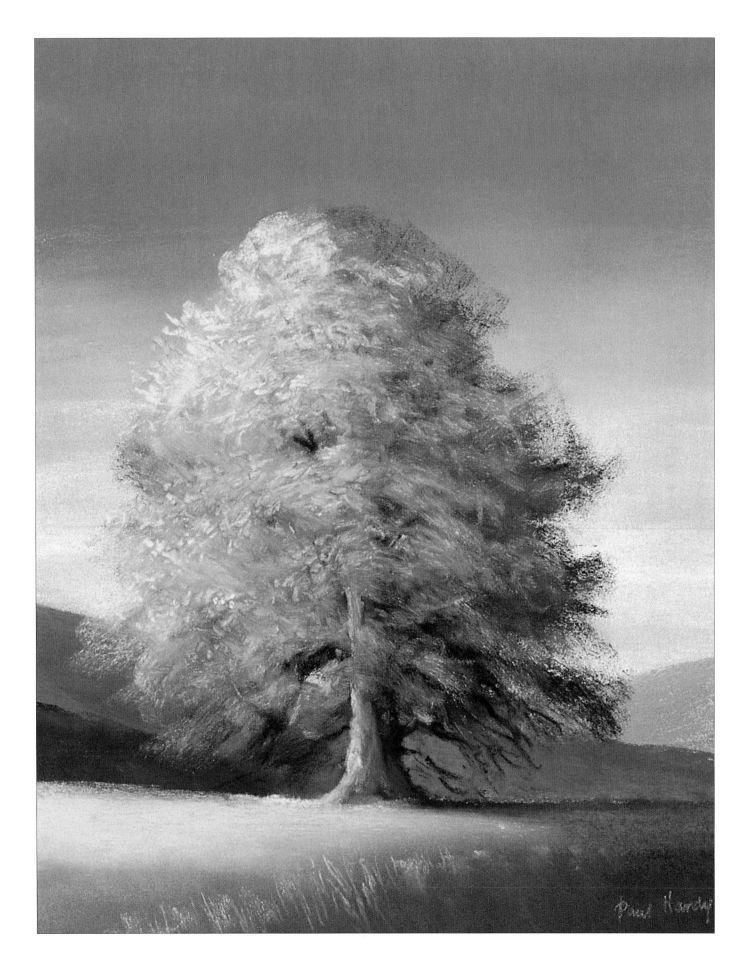

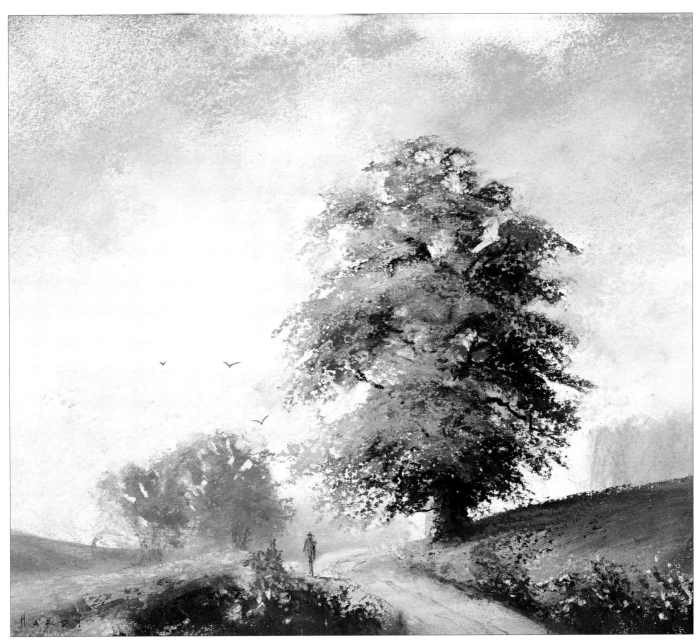

Moorland Road
51 x 38cm (20 x 15in)

Paths and roads in a landscape help lead the eye into a painting. In this scene, the person walking along the road not only gives a sense of direction, but takes the eye into the scene more quickly. The use of linear perspective – notice how the road diminishes in the middle distance – and aerial perspective – the cool middle distance tree echoes the warmer tones of that in the foreground – combine to lead the viewer further into the picture towards the distant hills. This type of painting encourages the viewer's own emotional response.

Opposite

The finished painting
23.5 x 29.5cm (9¼ x 11½in)

I added the suggestion of grass in the foreground by making a few marks with pale raw sienna and cadmium orange. Once again, I was not happy with the shape of the composition so I decided to crop it at the top and bottom.

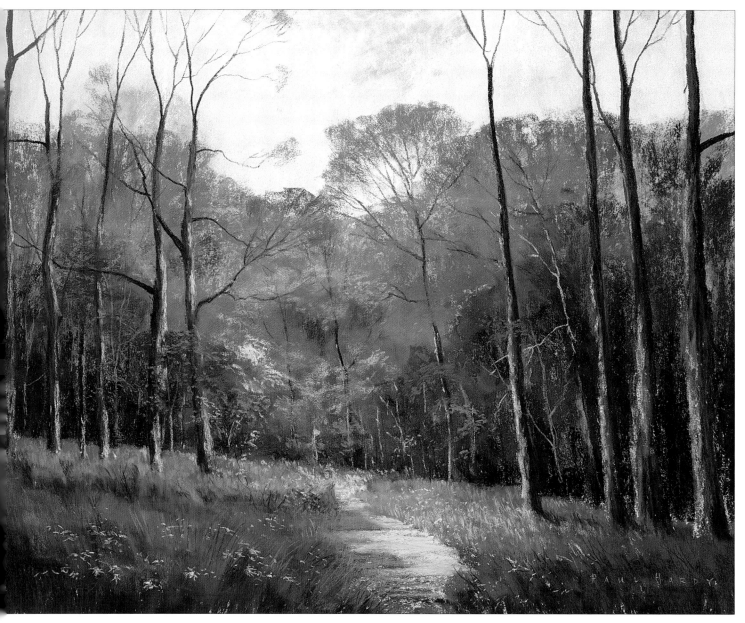

Woodland Glade
63.5 x 40.5cm (25 x 16in)

The sky has a small part to play in this painting, and is taken over by a medley of colour which creates depth and contrast. It is not difficult to imagine another world in this scene, nothing specific, but

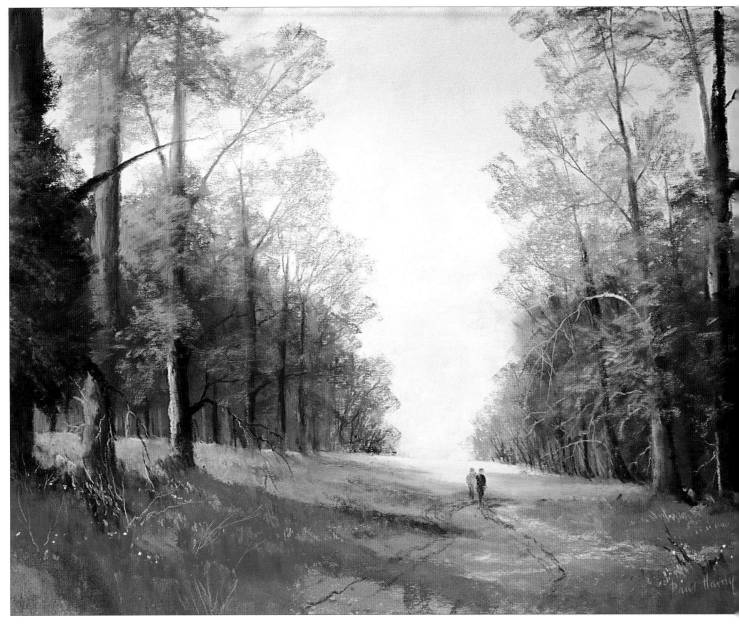

Two's Company
63.5 x 40.5cm (25 x 16in)

The season is obvious in this painting; it is a warm and sunny spring day, and the two people strolling through the bluebells are enjoying the flowers and each other's company. There is a sense of solitude but not loneliness, and their private world is open to public view for everyone to enjoy. This is an artist's inspiration and challenge.

A Sense of Peace

Water plays a prominent part in this painting and more or less dominates the composition. Water changes its mood very quickly, but, in this scene it is almost static, creating soft reflections on a mirror-like surface. The tones reflected in the foreground are quite dark, but they gradually get paler and paler towards the distant bank of the meadow. This is due to the fact that the distant surface of the water is at a more acute angle to the eye than that in the foreground and therefore reflects more light. The two trees balance the composition and hold it together by linking the river, its banks and the sky.

I painted this demonstration on a 560 x 380mm (22 x 15in) sheet of smooth pastel paper.

This tonal sketch, painted in sepia watercolour, was the inspiration for this demonstration.

Colours

Blue/grey	Lemon yellow	Ultramarine blue
Burnt sienna	Moss green	Vandyke brown
Cadmium orange	Prussian blue	Yellow earth
Cadmium yellow	Raw umber	Yellow ochre
Charcoal pencil	Red earth	White
Cobalt blue	Sap green	
Grey	Sepia pencil	
Hooker's green	Turquoise	

1. Sketch in the outline of the scene. Block in the top left-hand area of the sky with mid grey, then overlay the extreme top left-hand corner with dark cobalt blue. Repeat these colours in the water. Lay in turquoise over the centre area of sky and water, then add some cobalt blue and ultramarine blue. Block in the lower part of the sky with pale yellow ochre, taking it up into the blues, then apply touches of very pale yellow ochre. Again, repeat these colours in the water. Finally add white highlights on the distant stretch of water.

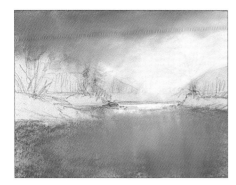

2. Blend all the colours together.

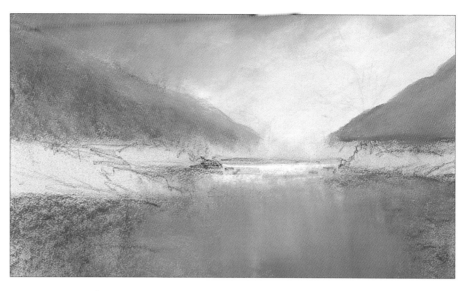

3. Use tones of sap green and Hooker's green to block the middle-distant hills. Use the same colours to indicate reflections in the water.

4. Use a mid blue/grey to block in the distant trees, then use deep Prussian blue to add shape and form. Finger blend just the bottom (dense) area of these trees.

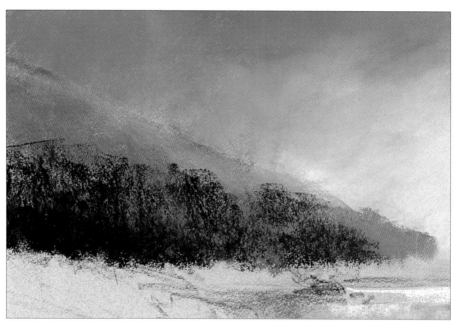

5. Continue building up the shapes of the trees with very dark Hooker's green, then use touches of dark burnt sienna to create the feel of autumn.

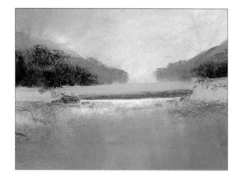

6. Use pale sap greens to block in the distant meadow, using the tip of the pastel to make strong marks, then overlay these marks with mid yellow ochre. Use raw umber to block in the distant river bank. Blend these colours into the distant trees.

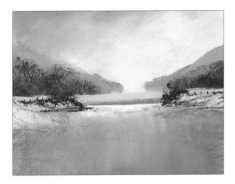

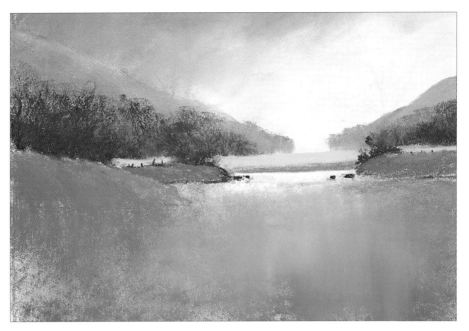

7. Use deep turquoise to block in the bushes on the river banks, to define the edges of the water and to draw in details such as the fence posts (at right and left).

8. Use the deep turquoise to add a few rocks adjacent to the right-hand river bank. Use yellow earth to block in the near banks of the river and their reflections, then overlay these marks with mid yellow ochre to create shape. Blend the colours together. Use dark moss green to add tone to the river banks and reflections.

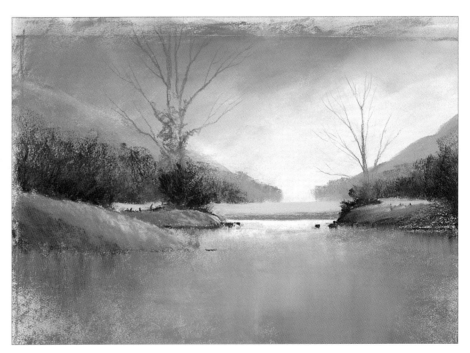

9. Use a charcoal pencil to darken the bushes, to redefine the edge of the water and to create shadows on the river banks. Use a finger to drag vertical reflections down into the water.

10. Add cadmium yellow highlights on the grasses. Use a sepia pastel pencil to define the skeletons of the trees on either side of the river.

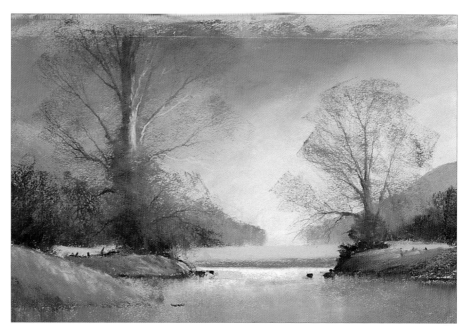

11. Use a charcoal pencil to develop the shadowed parts of both trees and accentuate their branches. Note the ivy growing on the lower part of the left-hand tree. Use a charcoal pencil to define the smaller branches – the branches against the pale sky are obviously more pronounced.

12. Break up some of the dark areas of the trunks with mid sap green. Use a very pale yellow ochre to create highlights on the trunks. Use the sides of mid Vandyke brown and yellow earth pastels to suggest areas of foliage. Redefine highlights on the trunks with a pale cadmium yellow.

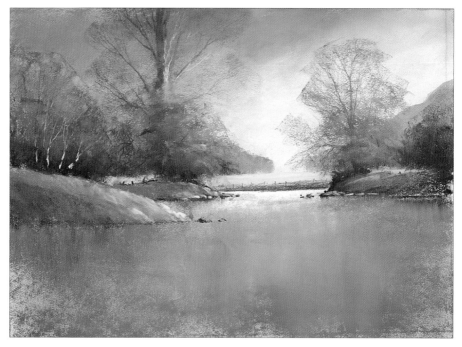

13. Use white to suggest thin tree trunks at the left-hand side. Start to develop the foliage on the trees using mid red earth, mid yellow ochre, cadmium orange and cadmium yellow. Use the same colours to suggest fallen leaves on the river bank.

14. Use a charcoal pencil to redefine the far river bank, to add an indication of fence posts on the distant meadow and to add more rocks. Use cadmium yellow to create highlights.

15. Use dark Prussian blue to add reflections close to the middle distant river bank, then, using the autumnal colours used to clothe the trees, block in their reflections.

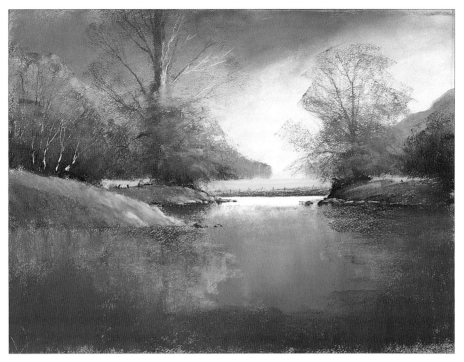

16. Darken the foreground area with very dark Hooker's green, then overlay this with lighter tones of the same colour.

17. Use the heel of your hand to drag reflections of these colours down into the foreground water.

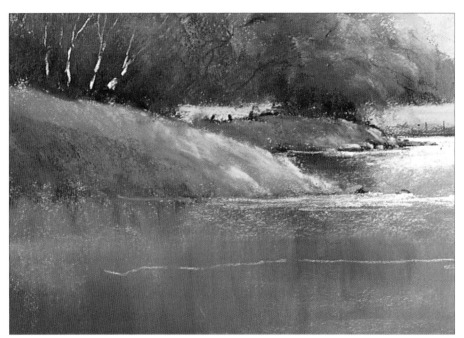

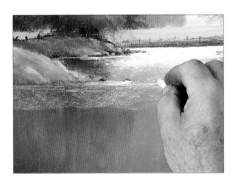

18. Use the side and tip of a white pastel to lay in highlights on the surface of the water.

19. Use the side of the pastel, add fine broad strokes of very pale lemon yellow on the water, then blend them vertically into the under colours. Finally use the tip of a very pale sap green pastel to add a few ripples.

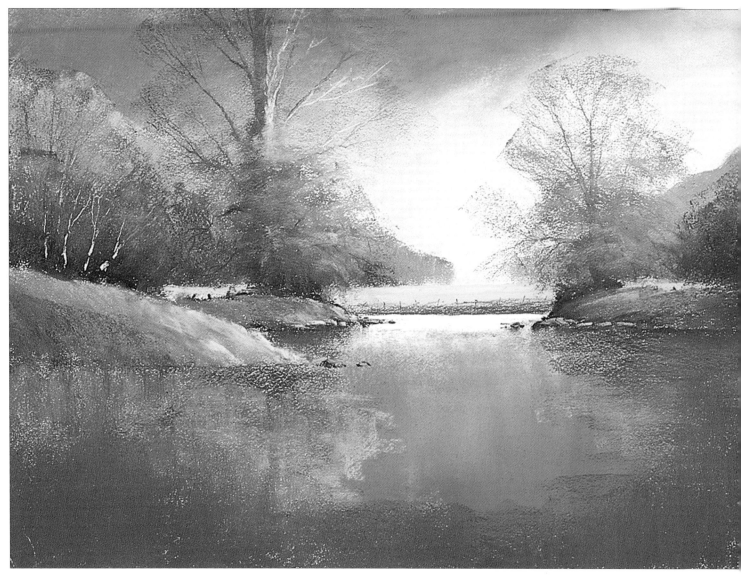

The finished painting
48.5 x 35.5cm (19 x 14in)

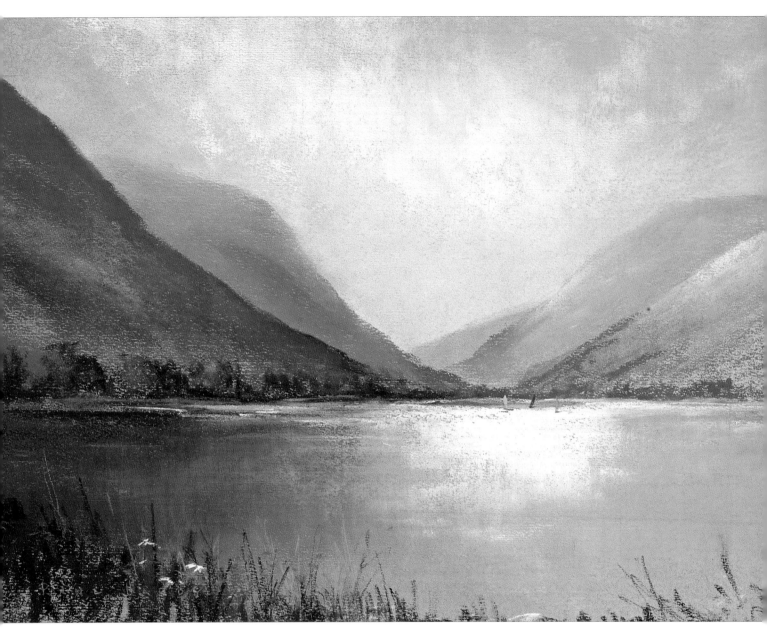

Away From it All
63.5 x 40.5cm (25 x 16in)

There is a sense of grandeur here on a large scale. The vista is panoramic, but, at the same time, it is within the view of the beholder. Comprehensive views that take in distance make spectacular compositions. We may be looking for a focal point, which I have defined by the almost incidental introduction of sailing boats on the water. Here, we have a balanced distribution of light and colour. There is no tension in this painting.

Opposite
The Old Bridge
38 x 51cm (15 x 20in)

Sometimes we see a scene where scintillating colour is dominant.
This can be unsettling, but, in this case, it is unified into a whole.
This is not a large painting and can be contained. The bridge is the
centre of interest, and everything else leads the eye to it.

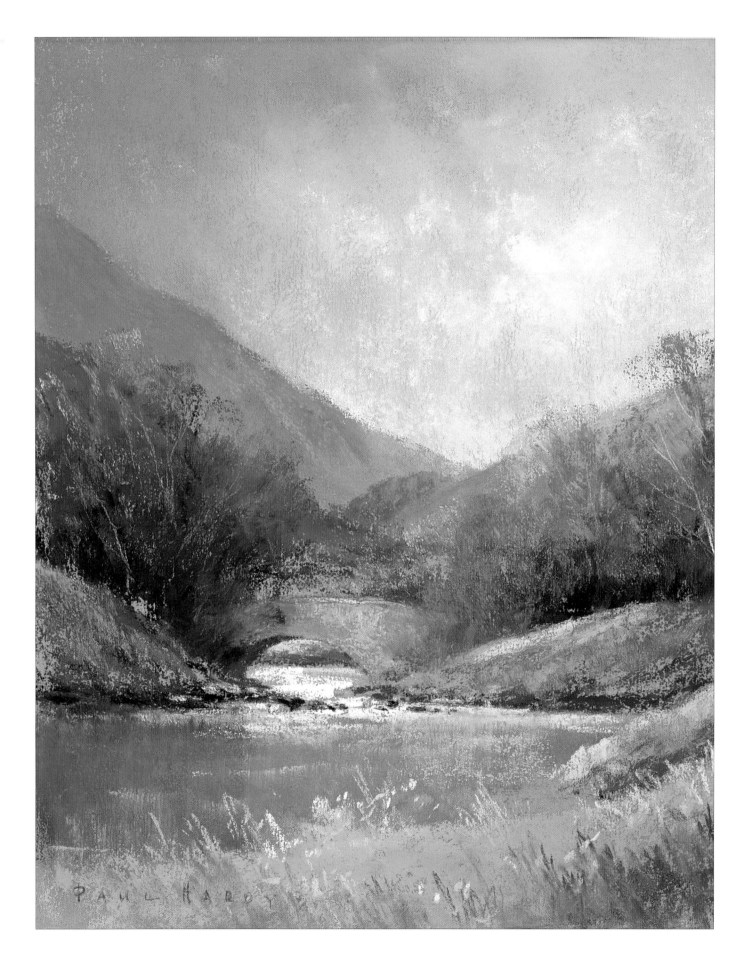

More Snow!
63.5 x 40.5cm (25 x 16in)

In winter, the landscape
is reduced to basics. Snow
does simplify everything
and softness prevails.
Contrast is an immediate
result, introducing shadow
patterns, dipping and rising
or stretching evenly over
meadows. The introduction of
colour is due to sunlight, out
of the picture, picking up the
remaining leaves on the trees.

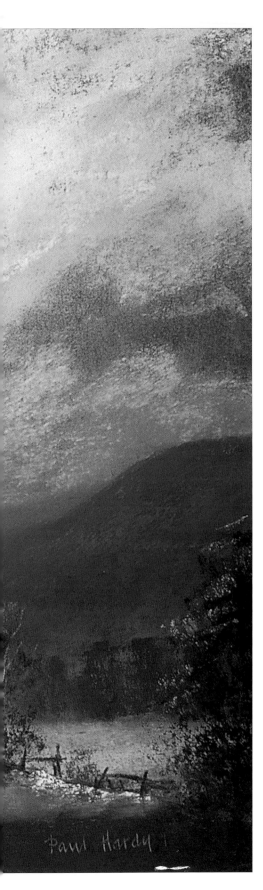

LIGHT IN PASTEL

by Paul Hardy

One of the most important aspects of painting in any medium is an understanding of light. Light enables us to see a subject, and the way the light strikes the subject helps us see it in three dimensions. If there is no light, there is no shape and form.

Light is an intangible quality. It is constantly changing; one minute a scene can appear flat and uninspiring, then, suddenly, the light changes and the same scene becomes very dramatic. Bright sunlight is often thought of as good light, but it is not always the best light for artists. Subdued or dappled light can often add drama to a painting. This is especially true if you use the available light to focus on a particular part of a composition and create a bright focal point in an otherwise bland scene.

Understanding the effects of light requires careful observation. You have to look at a subject and 'see' the relationship between lights, darks and mid-tones, and the strength of colours.

Compare highlights and shadows – in strong light, these are bright and dark respectively, but the contrast between them becomes less in diffused light. Look at reflected light and see the effect this has on shadow tones. Shadowed areas are as essential as bright highlights in any composition; both are part of the whole picture, and we cannot think of one without the other. Observe how the patterns created by light vary with the time of day and the prevailing weather conditions.

Pastel is a wonderful medium with which to explore all the exciting possibilities of light. Capturing light in pastels is an adventure that involves risks, but these have to be taken if we are going to realise the potential within us. In this section, I show you how I go about recreating the effect of light in all its glory. I hope the step-by-step projects and the finished paintings will inspire you to greater things.

Towards the Moor
44 x 33.5mm (17¼ x 13¼in)

I painted this scene on a warm summer evening. It was rather cloudy, but there was a top light that created soft shadows and muted colours. The two figures were added to bring the scene to life and add a sense of scale to the composition.

Mixing colours

Unlike most other media, pastel colours are mixed directly on the paper by adjusting colours as you work. There are three basic methods – blending, scumbling and hatching.

Blending
This is the most common colour mixing technique, and I use it on most of my paintings. Broad strokes (made with light touches of the side of a pastel stick) are used to lay on one colour. A second colour is applied on top, then the colours are blended together by rubbing with the side of your hand or a finger.

Scumbling
Here, different colours are applied with loose scribble motions, one on top of another. This free application creates a rich medley of colour without specific definition – the only blending that occurs is due to the pressure applied.

Hatching
This is a distinctive method of mixing colours. A series of parallel lines is drawn with one colour, then another series is drawn on top with a second colour at a different angle. This technique can be worked up with several colours, all at different angles, to produce strong tones. This method can be used to good effect in shadow areas.

Capturing light

Our natural source of light is the sun which, when high in the sky on a cloudless day, creates a wide tonal contrast – very bright highlights and very dark shadows – and warm colours. But, even on a bright day, distance (or atmospheric perspective) affects the tonal value and colour of objects that are further away than those in the foreground.

More often than not, however, other atmospheric conditions apply, and these can have a considerable effect on the amount and type of available light. On a very overcast day, for example, the tonal contrast is considerably reduced – dark tones become lighter and pale tones darker – but dramatic paintings can still be created.

So, capturing the drama of light is all about the relative lightness or darkness of the tones in a particular scene. Light gives life and vitality to a painting, and below and on the following pages are a few examples of different lighting conditions.

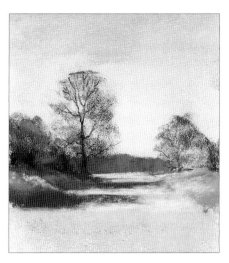

When you look at a subject through half-closed eyes, colour and detail are virtually eliminated and you see just the basic shapes and their tonal values.

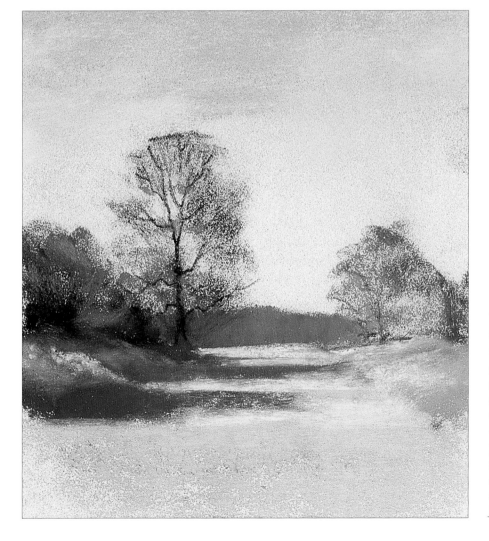

This scene was painted early on a fine autumnal morning.

The low sun limits the contrast between the light and dark tones, but it is just high enough to create patches of bright colour on the foliage and to cast long shadows across the landscape.

The warmth of the foliage is balanced by the coolness of the other parts of the composition. The sense of stillness and peace is accentuated by the simple sky and the horizontal shapes of the foreground shadows.

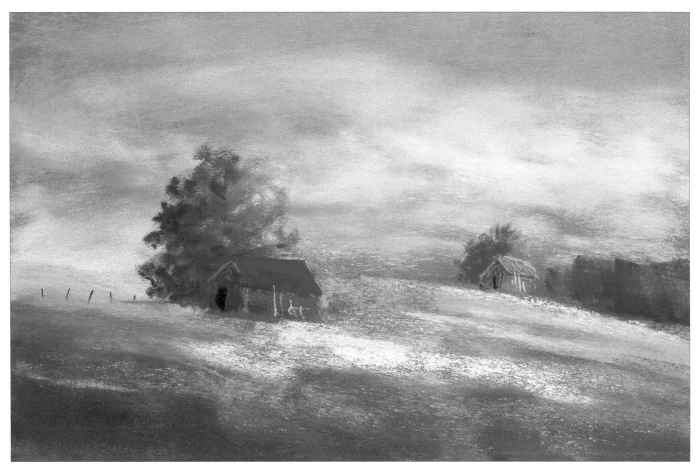

The two buildings in this sketch are actually the same size, but perspective has the effect of making the distant one smaller. The colour of their roof tiles is identical, but atmospheric perspective makes the more distant roof paler and cooler than the other.

In this simple composition the distant horizon is a long way away. There are several 'layers' in the landscape, and each becomes paler and cooler the further away they are. Note also how the marks used for objects in the foreground are more pronounced than those further back.

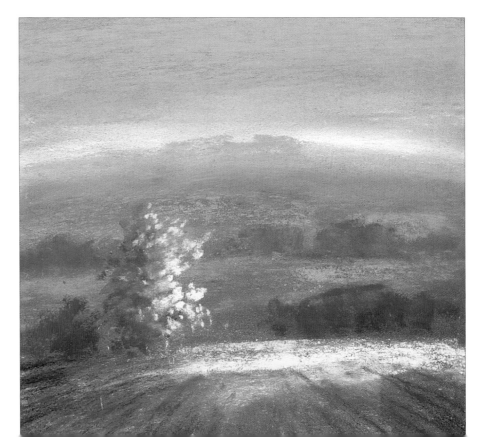

Here we have a snow-covered mountain set against a wintry sky. You can clearly see the wide tonal contrast between the bright sunlit snow and the deep shadows in the foreground. We all know that snow is white, but note how, on the shadowed side of the mountain, it takes on a blue-grey cast (a reflection of the colour of the dark sky above).

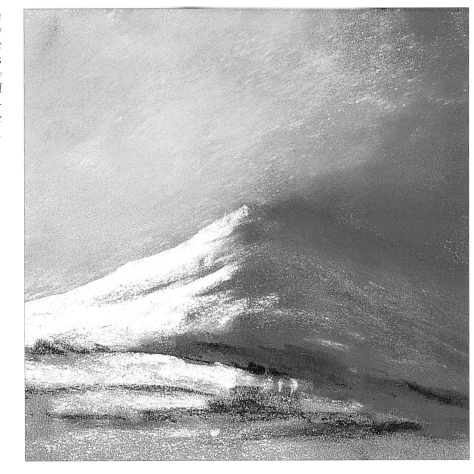

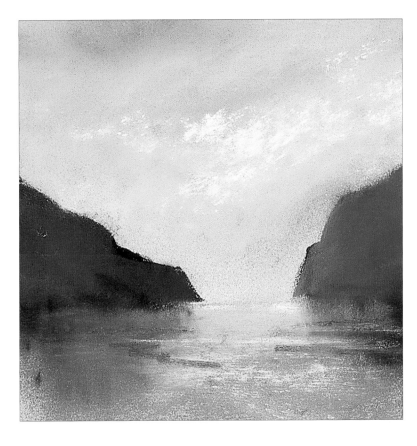

For me, the few minutes before and after sunrise is a beautiful time of the day. You never really know what to expect, and I find it exciting to stand in darkness and watch the colours of the day gradually reveal themselves. The colours and tonal patterns change every second, so you have to be quick to capture particular moments. Not every sunrise is spectacular, but each is unique. On this day, an early morning mist diffused the light, making the cliffs appear rather intense against a cool yellow sky. The wet beach in the foreground, illuminated by reflected light from the clouds overhead, holds the whole scene together.

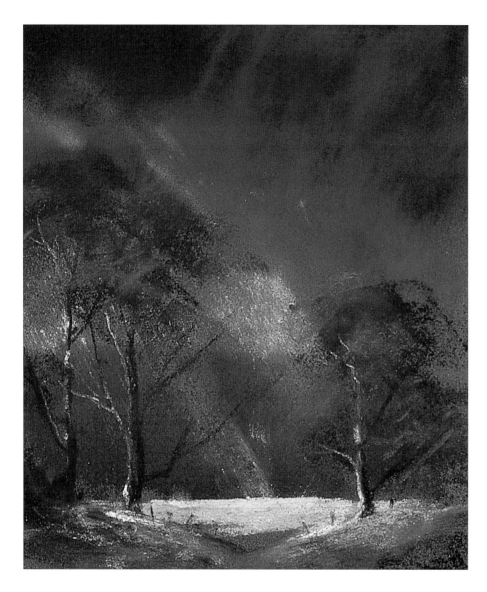

Here, sunlight filters through a break in dark storm clouds to illuminate a quiet woodland glade with a burst of bright light. The shafts of sunlight, visible against the dramatic dark sky, also highlight the left-hand edges of the large foreground trees.

The warm colours in the glade contrast well with the surrounding dark tones.

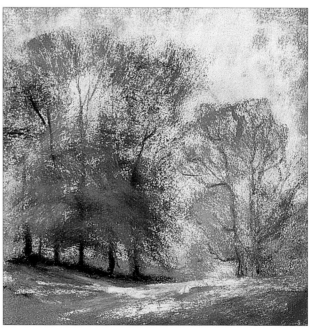

The atmosphere in this autumnal scene is enhanced by gentle sunlight from the left-hand side. The soft shadows, created by the light being filtered through the foliage, were just intense enough to complement the seasonal colours.

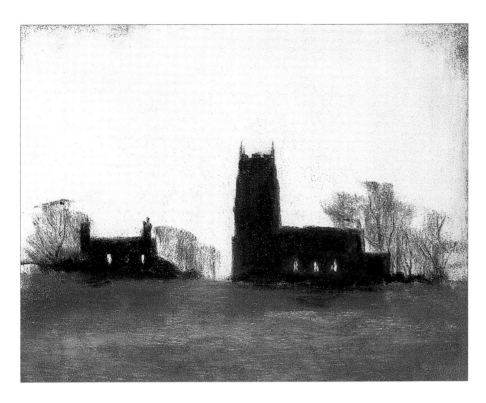

This is obviously a late evening scene; the sun has set but the sky is still quite light. The vertical walls of the church and cottage are dark silhouettes set against the light sky, but they still retain their shape and form, and some evidence of colour.

The relatively flat foreground has more colour because it is still lit by reflected light from the sky above.

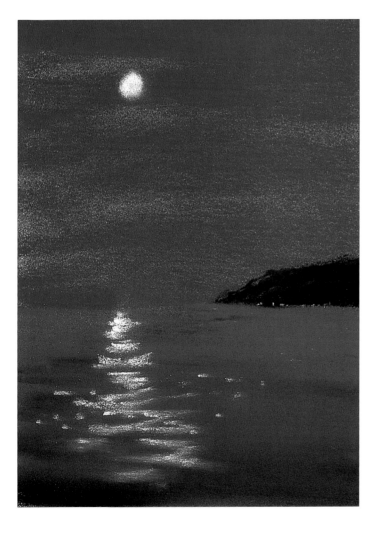

Moonlight (reflected light from the sun below the horizon) falls on a scene totally in shadow. This cool reflected light, of course, is not as strong as direct sunlight, but it is often strong enough to illuminate the landscape.

In this simple seascape, the bright reflection of the moonlight on the surface of the sea tapers back to the horizon line. The distant headland is very dark against the moonlit sky and sea, but it still has shape and form. The scene is brought to life by tiny bright marks that indicate a seaside town.

Overleaf

It always amazes me how the same scene can change so much throughout the year. The four sketches overleaf were painted in different seasons.

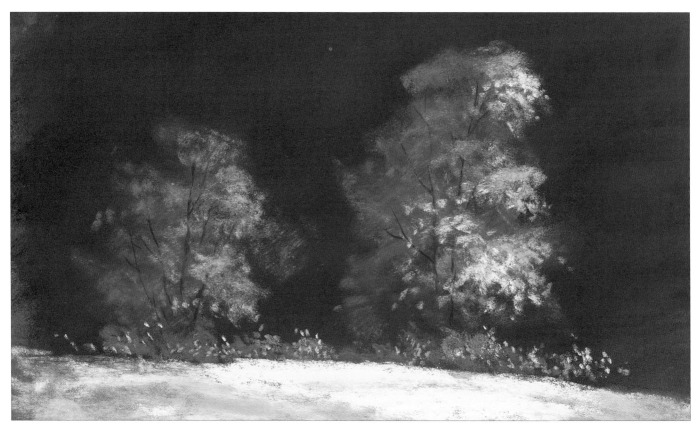

Strong and dramatic

Gentle and relaxing

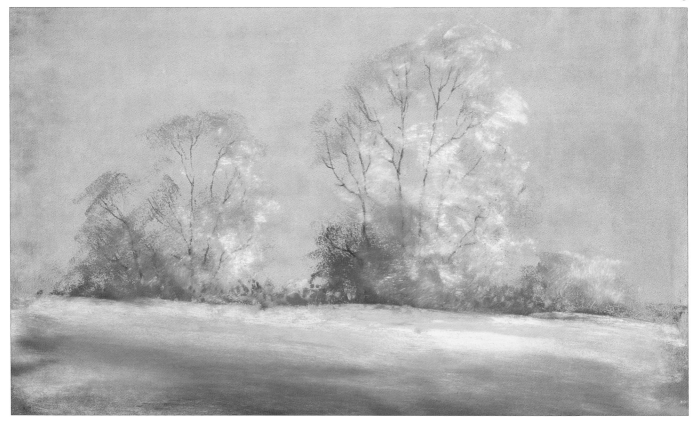

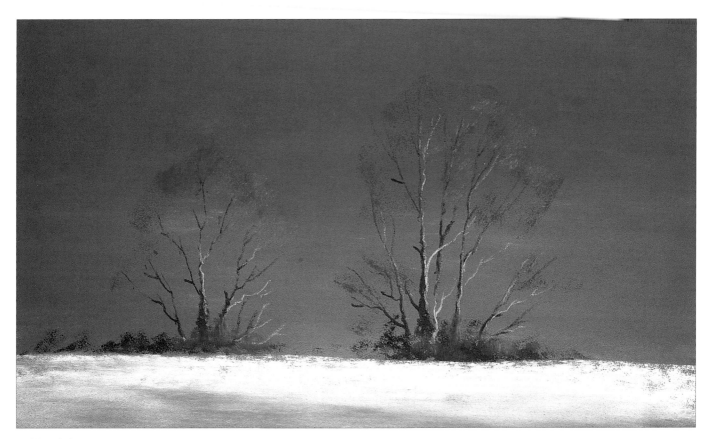

Cold and threatening

Warm and inviting

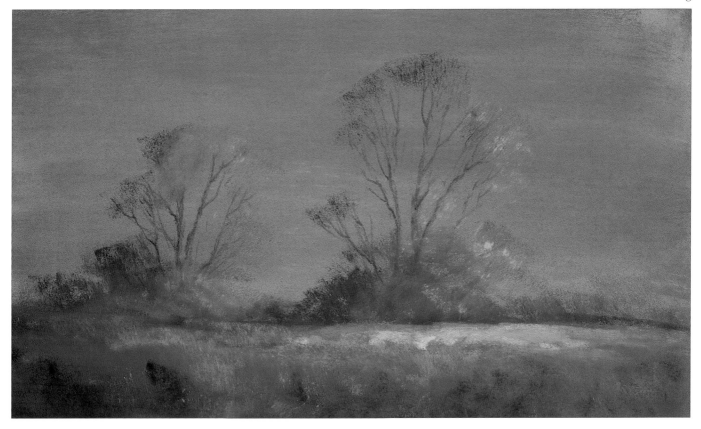

Autumn Scene

The landscape has so much to offer the artist, that I had to make a landscape my first demonstration. I have chosen a simple panoramic composition with a good interplay of light and shade, and distinct foreground, background and sky areas.

It is an autumn scene, with lots of warm colours in the foreground and middle distance that provide a balance to the cooler greys and blues in the sky.

You will need

Soft pastels:
 white
 cool-grey (dark)
 warm-grey (medium, dark and very dark)
 cool-blue (pale)
 warm-blue (pale and dark)
 purple (dark and very dark)
 cool-yellow (pale and medium)
 warm-yellow (medium)
 orange (pale, medium)
 cool-red (very pale)
 raw sienna (pale and dark)
 burnt sienna (medium and dark)
 warm-green (pale)
 charcoal pencil
Hard pastel: white
Pastel pencil: white
Charcoal pencil

This tonal sketch, worked up in situ *with charcoal and white pastel, was used in conjunction with my colour notes as the reference material for this demonstration.*

1. Use the charcoal pencil to draw in the horizon line and the basic outlines of the landscape on to the paper.

2. Use the side of a medium warm-grey pastel to block in the far distant hills on the horizon and define the bottom edge of the sky.

3. Use the side of the same grey pastel to block in the top part of the sky.

4. Use the side of a pale warm-blue pastel to block in the middle area of the sky.

5. Build up the colour with a dark warm-blue.

6. Add a very pale cool-red to the left-hand side of the sky.

7. Accentuate the top right-hand corner of the sky with a very dark warm-grey.

8. Tone this down with the medium warm-grey, then finger blend the colours together.

9. Now block in the basic cloud formation with a white pastel, taking this colour up into the greys and blues at the top of the sky.

10. Use the side of your hand to blend all the sky colour together.

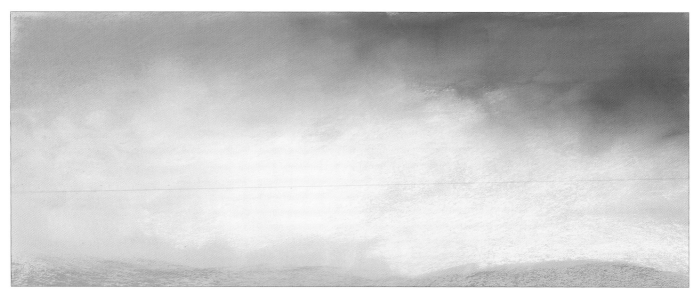

The blended sky colours after step 10

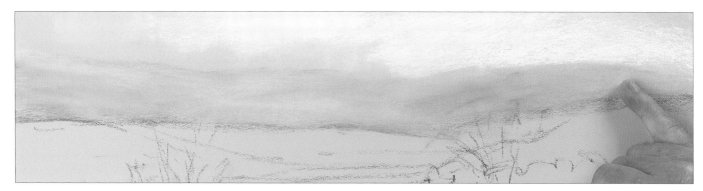

11. Overlay a pale cool-blue on the grey of the far distant hills, then, using a finger, blend the blue into the grey to create shape and form.

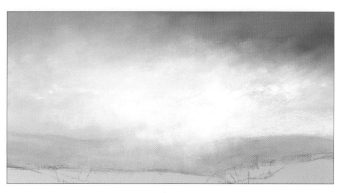

12. Add more white to emphasise the clouds, and bring some clouds down across the horizon.

13. Soften these new clouds slightly, and blend them into the horizon.

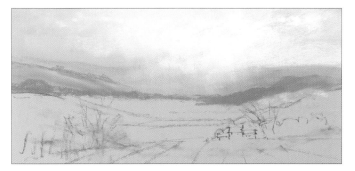

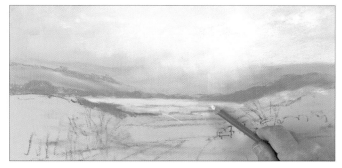

14. Use a medium warm-grey to indicate the shape of the middle distant hills. Use a dark warm-grey to block in the hedges and trees. Add touches of pale cool-yellow as reflected light on middle distant hills at left- and right-hand sides.

15. Use a medium warm-yellow to block in the meadow, then finger blend this on to the paper. Use the medium and dark warm-greys to define some hedges in the meadow, then use a white pastel pencil to soften their edges into the yellow.

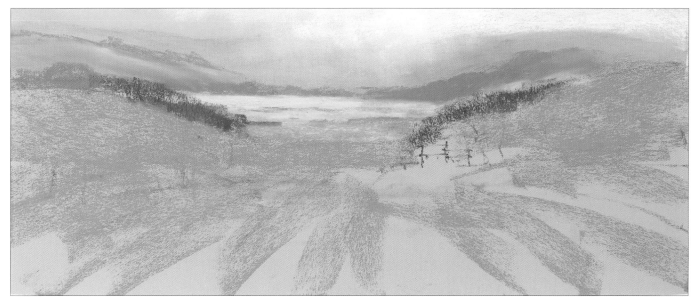

16. Use a dark cool-grey to block in trees on either side of the meadow. Use dark raw sienna to warm up the nearest part of the meadow. Extend this colour up across the hills on either side, then, using broad angled strokes, block in the foreground.

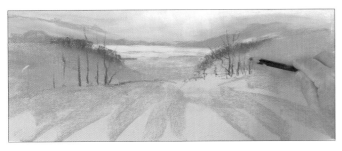

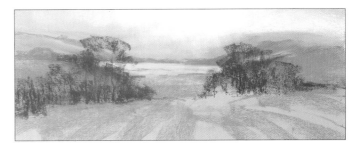

17. Blend the top of the hill into the trees, then add a few dark purple marks to the trees. Brighten the top of the left-hand hill with touches of pale orange, then use a charcoal pencil to draw in skeletons of trees at the bottom of the hills.

18. Use the side of a very dark purple pastel to block in foliage over the trees.

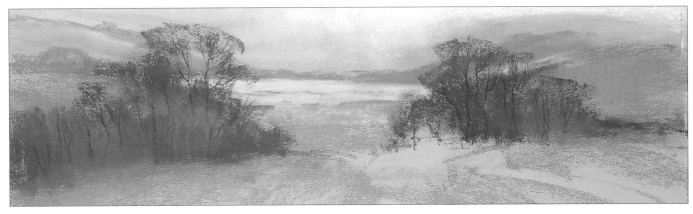

19. Working from the bottom upwards, use a finger to soften the marks, then use the charcoal pencil to re-establish the tree trunks and branches.

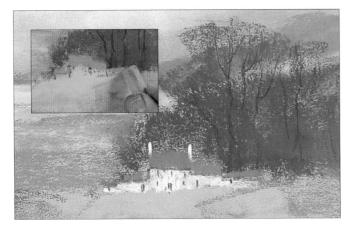

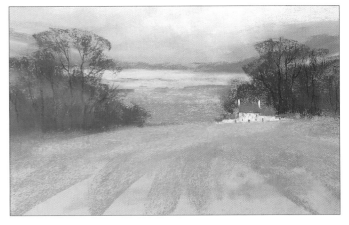

20. Use single strokes of a medium orange to block in the roofs of the building. Use the tip of a hard white pastel to block in the walls and chimneys. Use a charcoal pencil to define the edges of roofs and the doors and windows.

21. Warm up the foreground with strokes of pale raw sienna, then overlay this with touches of a medium warm-yellow. Add touches of a medium cool-yellow in the distance.

22. Work dark and medium burnt sienna pastels into the middle distant trees to suggest autumn foliage – skating over the surface to leave fine marks on top of the darker tones. Add touches of medium orange here and there to add light to the right-hand side. Overlay light touches of a pale warm-green into the top of the trees and across the foreground. Add a few highlights of a medium cool-yellow to the right-hand stand of trees.

23. Overlay the foreground area with a medium warm-grey, then use the edge of the pastel to denote furrows in the ploughed field to lead the eye into the painting. Finger blend these marks to soften them, accentuate the furrows with a medium burnt sienna, then blend the more distant parts of these marks.

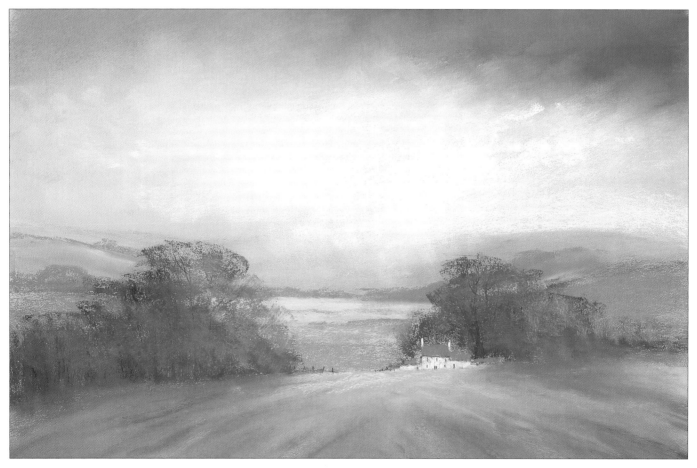

The finished painting
45.5 x 30.5mm (18 x 12in)

Having stood back to view the painting, I decided to add a few small clouds, a fence in the middle distance, and some angled strokes of pale cool yellow to brighten the far end of the ploughed field. I also decided to reduce the foreground to create a wide vista.

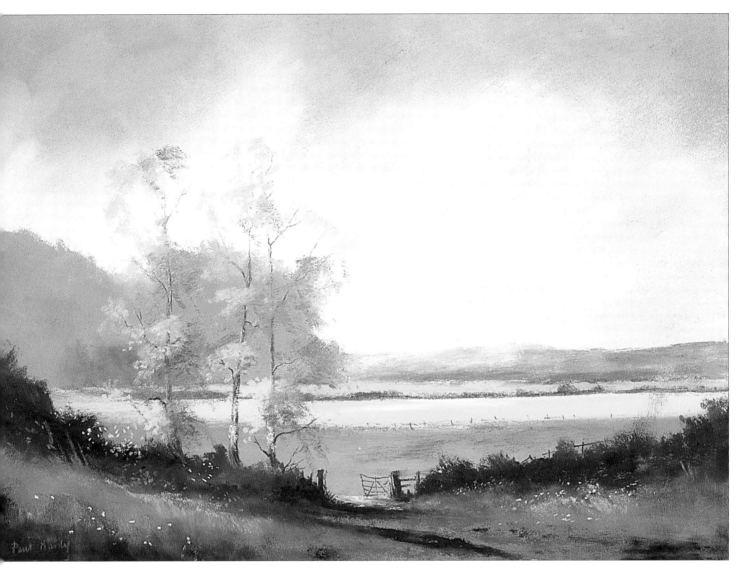

Meadowlands
36.5 x 26cm (14½ x 10¼in)

This simple landscape was painted on a clear evening in late spring. The horizontal structure of the middle distance suggests a sense of calm, but this is balanced by the drama of the diagonal lines of the hedges and long shadows in the foreground. The group of trees link the foreground to the sky and hold the composition together. Notice how the perspective is enhanced by placing the fine detail of the foliage and tree trunks against a less fussy background.

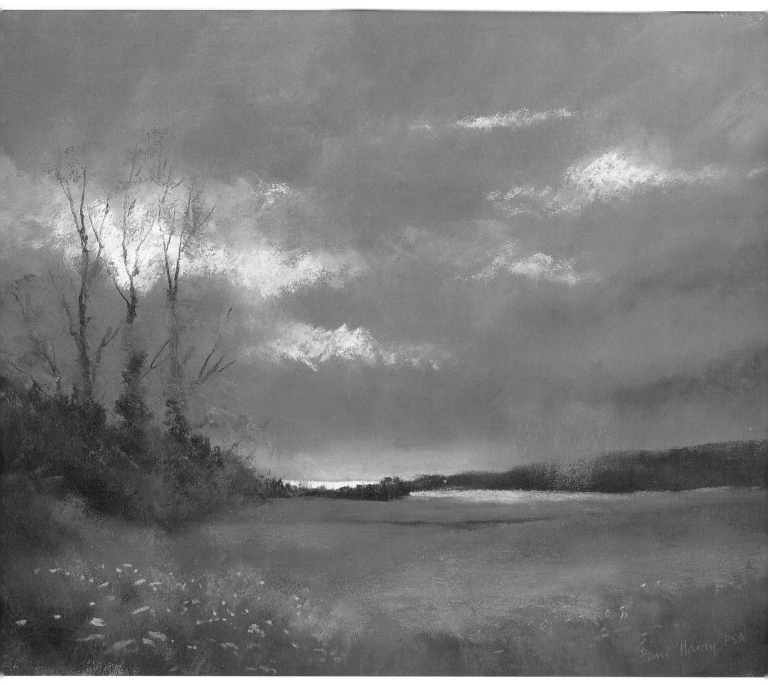

Bright Interval
41 x 33.5cm (16¼ x 13¼in)

*Another landscape on another day – completely different in all respects to the one opposite
– but still worth painting. The subdued light from the overcast sky muted all the colours
and softened the shapes of the foreground objects. Tonally, there was hardly any difference
between the foreground and the sky areas, but the really dark tones along the horizon, the
bright patches of sunlight on the distant fields and the breaks in the clouds combined to
make a dramatic composition.*

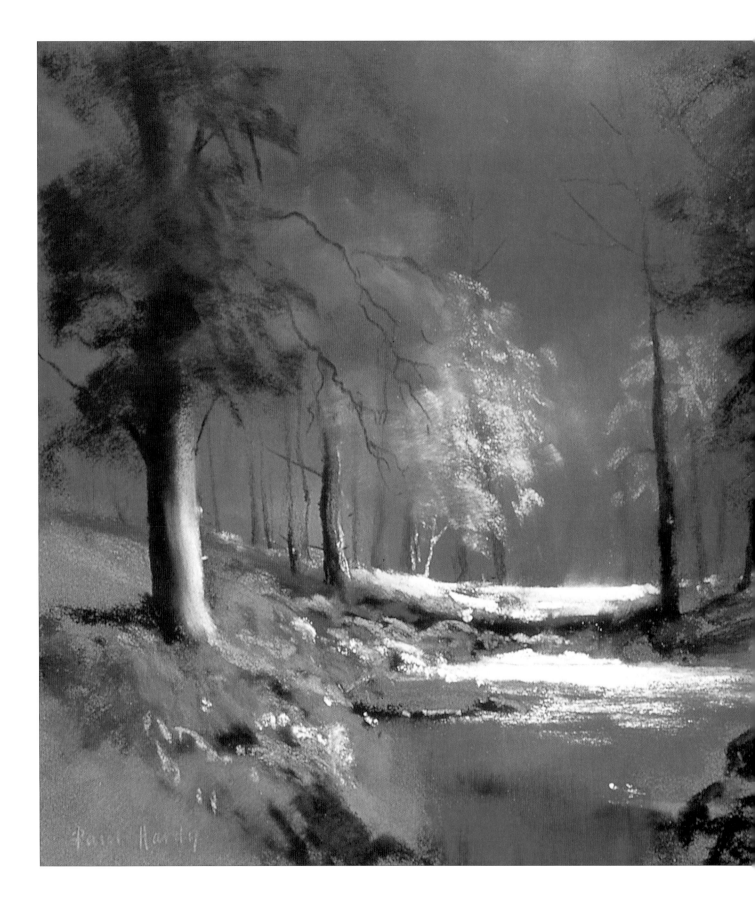

Highlights
31.5 x 23cm (12½ x 9in)

Shafts of sunlight, penetrating the canopy of tall trees, brought this tranquil scene to life by creating colourful highlights on the foliage and bright reflections on the surface of the water. Soft blended patches of foliage in the shady areas contrast with the patchwork of bright, more defined shapes in the foreground.

Seascape

The subject of this step-by-step demonstration is a place I visit at least once a year, and each time it presents a different challenge. It is an estuary, where the depth of water in the river changes with the tide. On this particular visit, the tide was low, exposing the gravel surface of the river bed.

The light source, which was behind me, created the bright colours on the sandy beaches and highlighted the distant sea. I introduced drama by setting these against a dark sky.

You will need

Soft pastels:
 white
 cool-grey (very pale, pale, medium and very dark)
 warm-grey (pale, medium, dark and very dark)
 violet (pale)
 cool-blue (pale)
 warm-blue (medium and dark)
 black-green (dark)
 cool-yellow (pale)
 raw sienna (medium and dark)
 burnt sienna (very dark)
Pastel pencil: white
Charcoal pencil

I used this tonal pencil sketch as the reference for this demonstration.

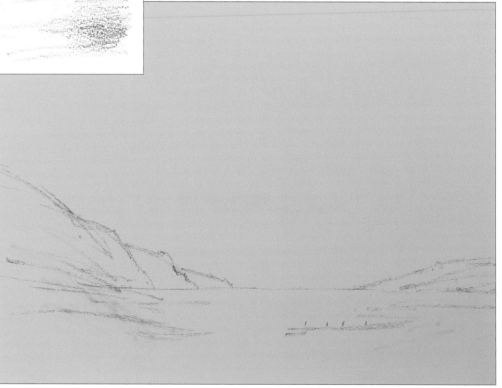

1. Referring to the tonal sketch, use a charcoal pencil to draw the basic outlines of the composition.

2. Use a dark warm-blue to block in the whole of the sky.

3. Use the side of your hand to rub in the colour leaving a few patches of the paper showing through.

4. Overlay all the sky with a dark violet, then rub this into the undercolour.

5. Use a very pale cool-grey to lay in clouds in the centre of the sky, and a very dark cool-grey for some darker clouds at the top and right-hand side.

6. Use a white pastel to define the horizon line, then add a few more strokes to denote the distant part of the sea.

7. Use a medium warm-grey to block in the distant right-hand headland. Leave some of the paper showing through as highlights.

8. Overlay the lower part of the cliff with pale violet, then blend the colours together. Again, leave some of the paper showing through.

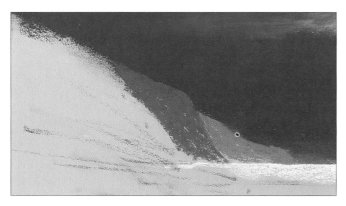

9. Work up the middle section of the left-hand cliffs with the pale violet, then lay in the furthest cliffs with the medium warm-grey.

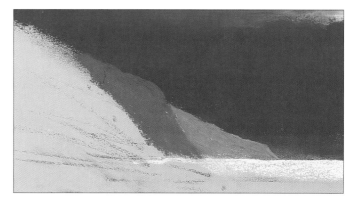

10. Blend the pastel on the middle cliff, then overlay the distant grey cliff with scribbles of a medium warm-blue.

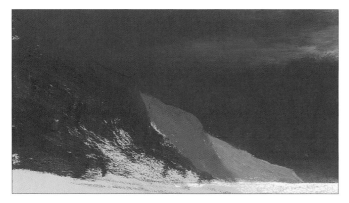

11. Use a dark black-green to block in the nearest cliff, leaving some of the paper showing through at the bottom as a highlight picking up light from the sky.

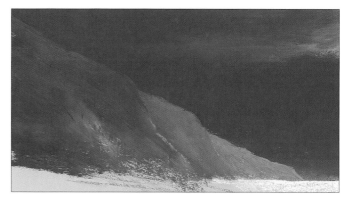

12. Overlay the cliff with a medium cool-grey, accentuate the cliff edge with a pale cool-yellow, add touches of the same colour to its lower parts, then blend the colours together. Having stood back to look at the painting, I decided to dull down the middle cliff with touches of pale warm-grey.

13. Use a white soft pastel to indicate spray from the waves crashing against the cliffs.

14. Use a dark violet to define an area of rocks in front of the cliffs and to accentuate the breaking waves behind them.

15. Use a white pastel pencil to accentuate and highlight the edge of the middle cliff.

16. Darken the bottom of the right-hand cliff with a dark warm-grey, then blend this into the undercolours to create shape and form. Use a medium raw sienna to suggest a grassy bank on the top of the cliff.

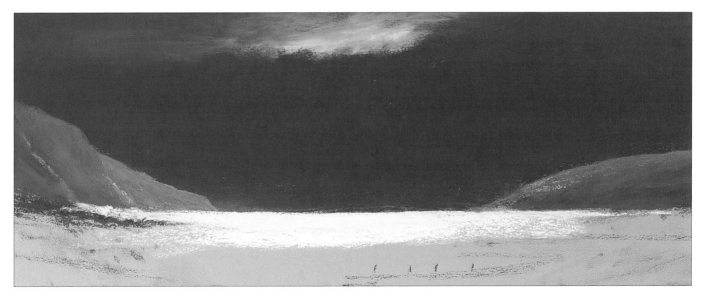

17. Enhance the distant sea with more white, extending the water across below the right-hand cliff and in front of the left-hand rocks.

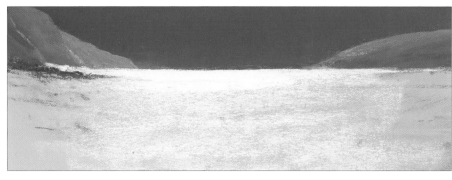

18. Working from the bottom upwards, use a pale cool-blue to block in the foreground sea, taking it just up into the distant white area. Using a pale cool-yellow, lightly skate over the blue to leave just the merest indication of light.

19. Now, using downward movements of the side of your hand, rub the colours together.

20. Use the edge of a white pastel to create a series of horizontal ripples that just break the surface of the water.

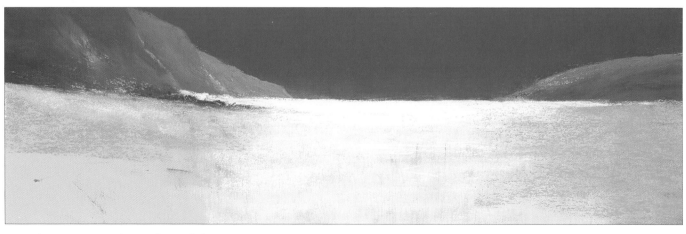

21. Skating across the surface of the paper, use a medium raw sienna to suggest the sandy beach. Overlay touches of the pale cool-yellow on the left-hand beach.

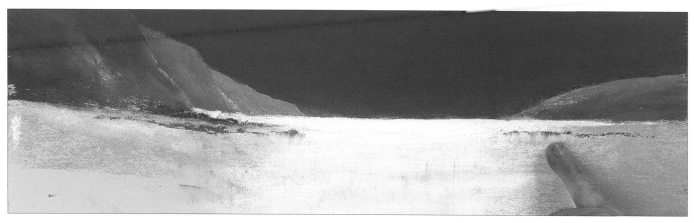

22. Use a very dark warm-grey to lay in more rocks on the left-hand beach and the merest suggestion of some more on the right. Use the tip of your finger to pull down reflections into the water.

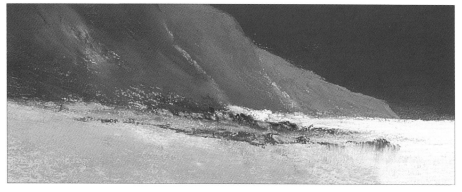

23. Use the medium cool-grey to add highlights among the rocks under the left-hand cliffs.

24. Use the charcoal pencil to reinstate the old breakwater posts and their reflections.

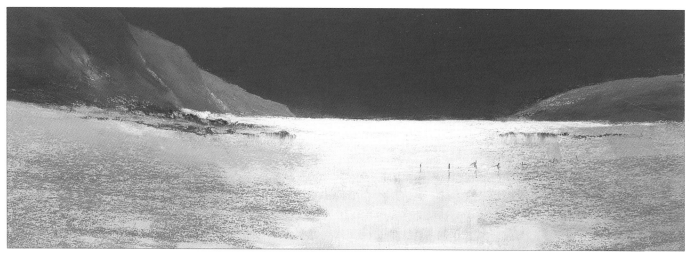

25. Use a pale cool-grey to tone down the sand banks at either side, and to block in the rest of the beach at the left. Overlay the foreground area at each side with a dark raw sienna.

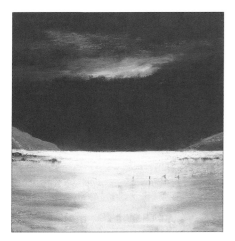

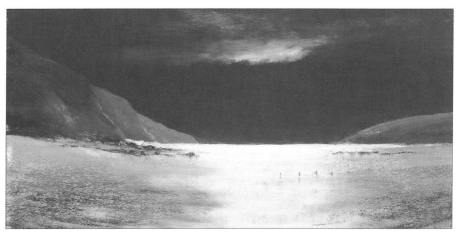

26. Finger blend the edges of the sandy beaches into the water.

27. Drag the side of a very dark burnt sienna pastel across the surface to denote shingle in the foreground.

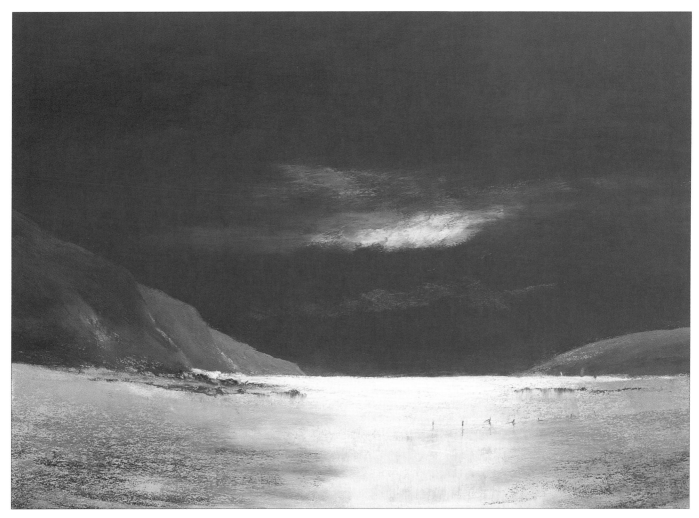

The finished painting
45.5 x 32.5cm (18 x 12¾in)

Having looked at the painting at the end of step 27, I decided to intensify the whites in the cloud formation. I also decided to add a few tiny bright spots of colour in the form of sailing boats set against the right-hand cliff.

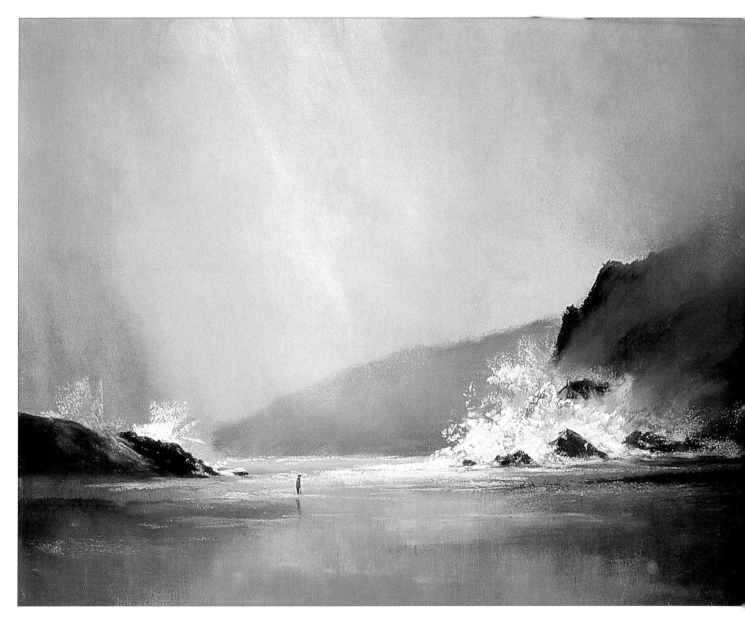

Isolation
30.5 x 21.5cm (12 x 8½in)

Waves crashing on a rocky coastline are always dramatic, but, in this very remote location, I also wanted to convey the sense of isolation. The combination of the sombre sky, with its suggestion of rain, and the muted colours of the cliffs and beach contrast well with the bright spray. The small figure provides depth and scale to the scene, and emphasises the loneliness of the beach.

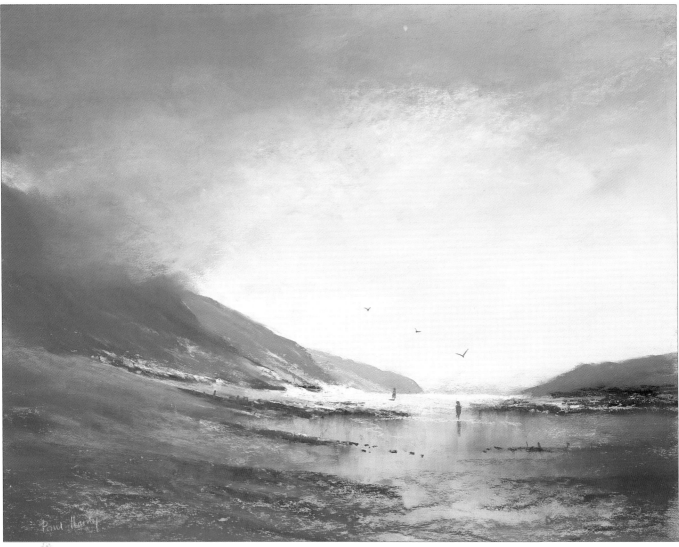

Red Sail
44 x 28cm (17¼ x 11¼in)

This is a painting of the same scene as the Seascape demonstration, again at low water but at a different time of day, with the light source much higher in the sky. It was not a particularly bright day, but there was sufficient light to create a moody atmosphere with a rich colour scheme.

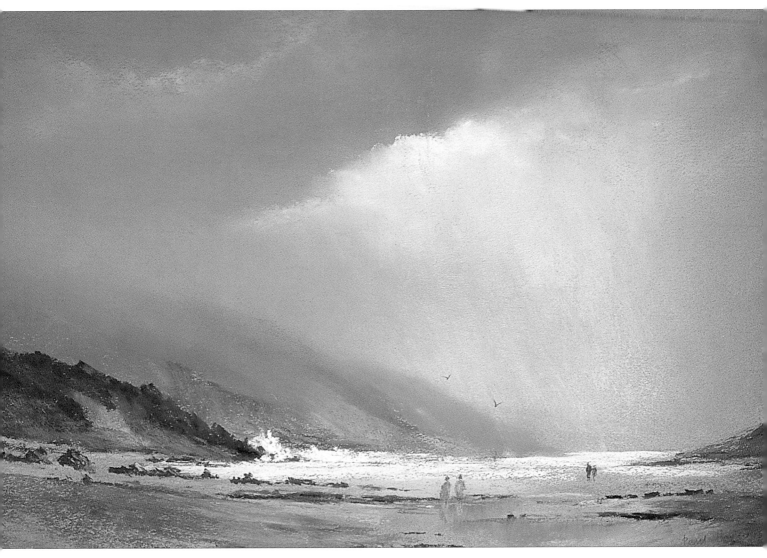

Ominous Sky
47.5 x 36cm (18¾ x 14¼in)

I painted this version of the estuary on a rather cold misty day with low clouds rolling across the cliff tops. The soft atmosphere creates a certain mystery. The drama of the scene is emphasised by a low horizon and a wider than usual seascape format.

Townscape

This final step-by-step demonstration is a townscape. This is a scene in a city that has an abundance of good subjects for the artist.

This particular view caught my eye because of the wonderful range of colours produced by the warm glow from the evening sky. The light source, out of the picture at the left-hand side, created a pattern of light and dark between the buildings. The shadows on the pavement and road were rather intense, but the colour scheme of the whole scene had a balanced tonal value.

The perspective of the buildings, simple boxes that get smaller and narrower as they get further away, had its own appeal, and this was emphasised by the colours which became cooler and weaker as they receded into the distance.

You will need

Soft pastels:
 white
 warm-blue (very pale, pale and medium)
 warm-grey (very pale, pale and medium)
 raw sienna (dark)
 orange (medium and dark)
 yellow ochre (pale and medium)
 cool-yellow (very pale and pale)
 black-brown (dark)
 red-brown (medium and dark)
 crimson (very pale)
 violet (pale, medium and very dark)
Pastel pencil: white
Charcoal pencil

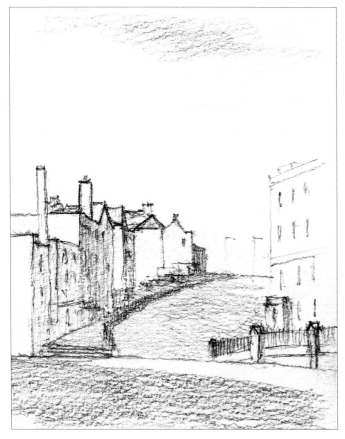

Pencil sketch used as the reference for this demonstration

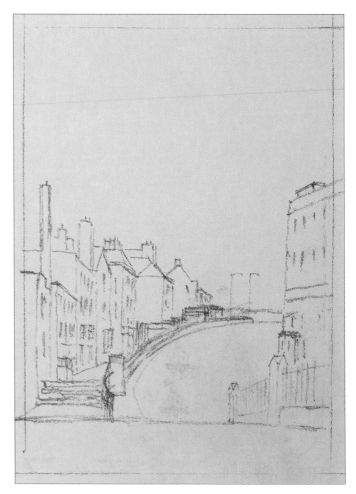

1. Use a charcoal pencil to draw the basic outlines.

116

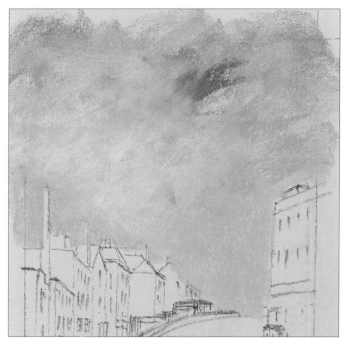

2. Cover the sky area with a medley of colours – pale and medium warm-blue, medium and dark orange, dark raw sienna, medium yellow ochre and pale cool-yellow – making the left-hand side of the sky lighter than the right.

3. Blend the colours together.

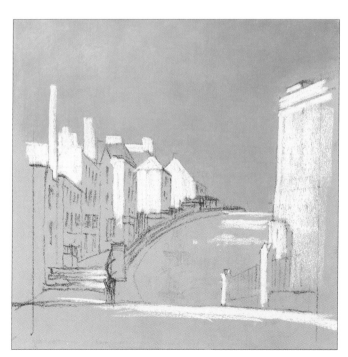

4. Use white to lighten the left-hand side, then gently rub this into the background colours.

5. Using a very pale cool-yellow, block in the sunlit sides of the buildings and sunlit areas in the road.

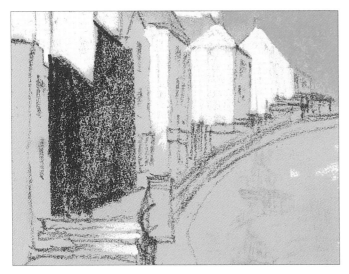

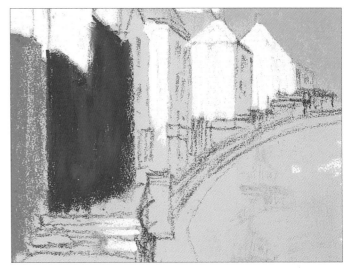

6. Use a dark black-brown to block in the shadowed side of the brick buildings.

7. Overlay the black-brown with a dark warm-blue, then finger blend the colours together. Block in the nearest building with a medium red-brown.

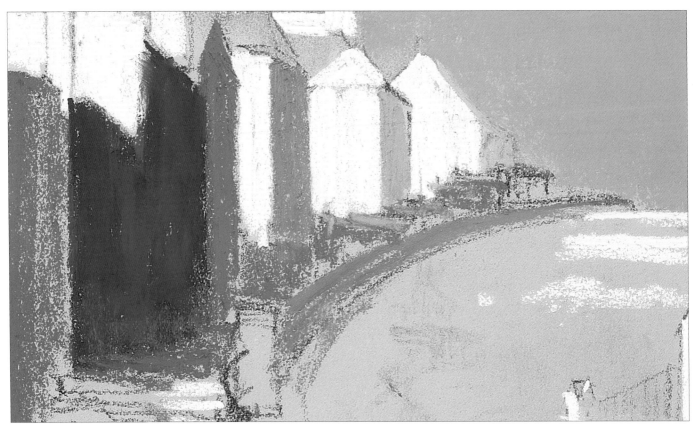

8. Use a pale violet to block the shadowed wall of the building with the gable end and the shadowed areas on the gardens. Block in the other buildings up the hill with medium, pale and very pale warm-greys. Overlay the wall of the first and last of these grey buildings with medium and very pale warm-blues respectively. Use the medium warm-grey to roughly block in the curving wall, then add marks to suggest stepped areas on the pavement.

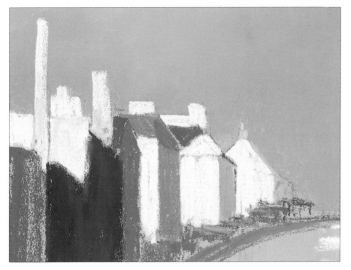

9. Scribble a very pale crimson over the chimneys to create texture. Block in the roofs with dark red-brown, a medium warm-grey and a very dark violet.

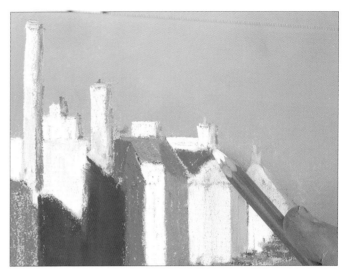

10. Define the shadowed sides of the chimney with touches of pale violet, then use a white pastel pencil to soften the marks and define the shapes.

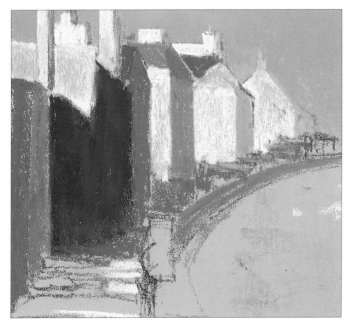

11. Overlay the front wall of the nearest building with medium warm grey. Knock back the brightness of the sunlit walls with a pale yellow ochre.

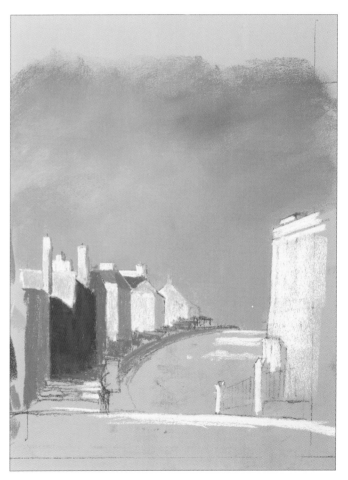

Having stood back to look at the painting at the end of step 11, I decided that the left-hand chimney was too tall. I made it shorter by overpainting it with the sky colours.

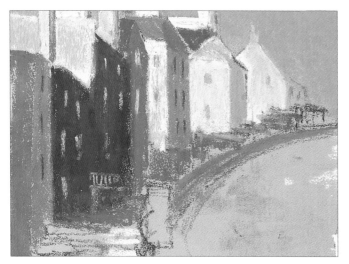

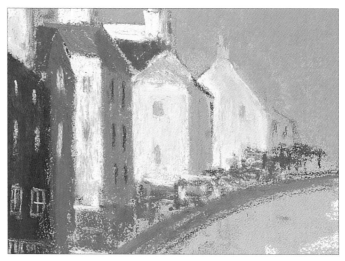

12. Using the tips of white and very pale warm-blue pastels, make small marks to indicate the windows on the darker buildings. Use the charcoal pencil and the medium warm-grey pastel for those on the paler buildings. Make the marks narrower and smaller as the buildings recede into the distance.

13. Use the very pale cool-yellow to add highlights to stepped areas on the pavement, and touches of the medium red-brown to denote some of the brick walls in the small front gardens.

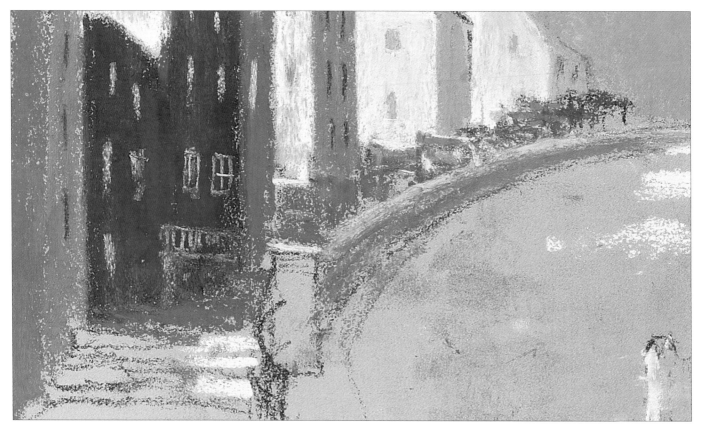

14. Establish the pavement in front of the gardens with a pale warm-grey, then add bright accents of yellow and orange to denote flowers in the sunlit parts of the gardens.

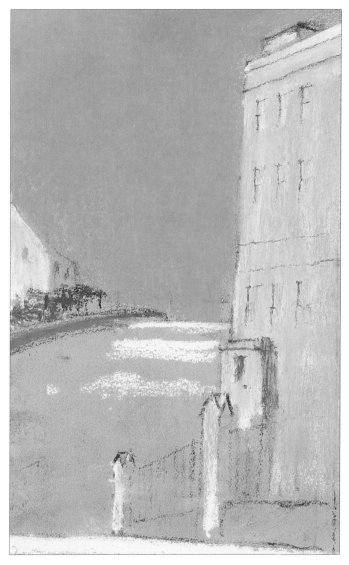

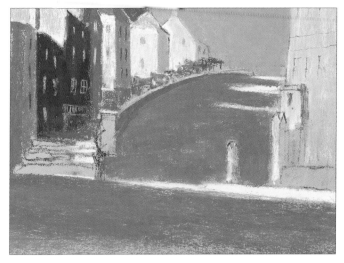

16. Use a medium warm-grey to block in the surfaces of the road in the foreground and up the hill, then overlay these areas with a pale violet. Overlay the curving wall with a medium violet.

15. Use the pale yellow ochre to knock back the sunlit walls on the right-hand building. Use the very pale warm-blue and the pale warm-grey to indicate the windows, then re-establish the shapes with the charcoal pencil.

17. Develop the steps with medium warm-grey and medium violet. Block in the pillar in front of the curved wall with dark black-brown.

18. Overlay the patches of sunlight on the hill with pale cool-yellow.

121

19. Re-establish the wall in front of the right-hand building, then use a charcoal pencil to define the railings. Add the indication of railings by the left-hand steps.

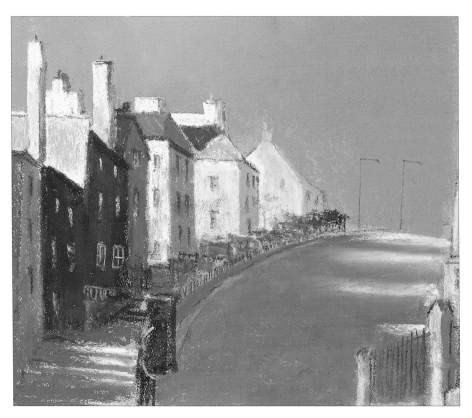

20. Use a charcoal pencil to add fine detail: the two lamp posts; the railings along the pavement; and the deep shadows under the eaves and round the windows of the left-hand buildings.

Having stood back and looked at the composition at the end of step 20, I was not happy with the shape of the right-hand building. I reworked it to create a tiered structure, added a cast shadow to the right of the entrance, then reinstated the railings.

21. Intensify the area of sunlight on the foreground stretch of road with a very pale cool-yellow. Use a dark warm-grey to intensify the shadowed area at the bottom of the hill, reducing the strength as you work up the hill. Use the same colour to increase the depth of shadow at the left-hand side of the foreground.

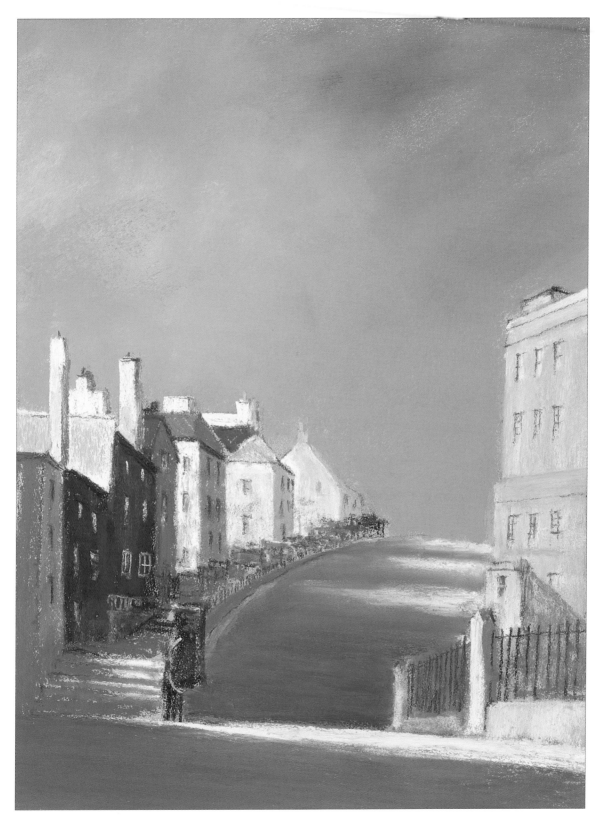

The finished painting
24 x 32mm (19½ x 12½in)

Having stood back to look at the composition after step 21, I decided that the distant lamp posts distracted the eye, so I removed them by overlaying some more yellow and blending this into the sky.

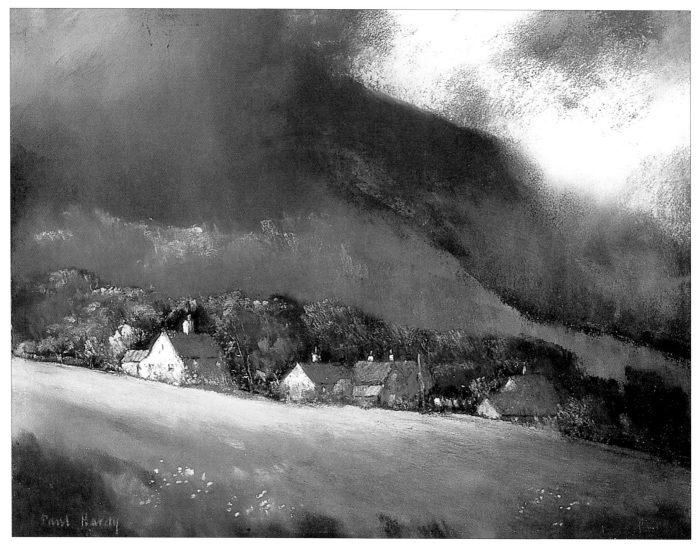

Welsh Valley
30 x 22cm (11¾ x 8¾in)

When I first saw these buildings, nestling in the folds of the Welsh mountains, the light was such that they were hardly visible against the dark background tones. Suddenly, the evening sun broke through the storm clouds and lit up the foreground with rich warm colours – raw sienna, burnt sienna and yellow ochre. The reflected light, bouncing off the west-facing walls of the buildings, gives added depth to the composition.

Going Home
55 x 39cm (21½ x 15¼in)

This is another composition that would have looked quite drab had it not been for a break in the clouds. The light, although weak, was more than enough to brighten the foreground and highlight the buildings against the misty background. Note how the tonal value of each building varies with its relative position to the light source. The really bright roof of the middle cottage in this composition suggests recent rain. Telegraph poles are often regarded as distractions, but, here, they provide a link between the two sides of the composition, and help the eye move around the painting.

FLOWERS IN PASTEL

by Margaret Evans

This section is written for those who want to paint the 'suggestion' of flowers, not an accurate botanical illustration. Whatever subject I paint, I strive to give an impression, rather than the actual detail, and I relish a painting which leaves something to the imagination.

This loose style can be achieved either with pure pastel, or with pastel which has been under-painted with various media, including watercolour, acrylic and gouache. Pastel comes in so many forms that my aim is to inspire you with the ideas in this section, not to suggest that you copy them. For the best results, you should be willing to improvise and experiment, allowing your own personal expression to develop. Try adding water to your pastels to find out whether they are soluble; some are, and some resist water, which is in itself an interesting effect. Try diluting your pastels with turpentine to see if they react, and enjoy the surprises that result. There will be some happy accidents; other experiments will fail – but you will at least have learned something.

Pastel is such an expressive medium, with its ability to capture the essence of the subject and its huge range of delicious colours and tints, which are particularly suited to flower painting. Although I teach the use of a limited palette for painting, these principles are abandoned when I come to paint flowers. Then, I have the opportunity to use all those wonderful colours which seem too loud, too extravagant and too vibrant to use for other subjects.

I tend to simplify the painting I am doing into three simple stages: sketching in, blocking in and building up. I then allow myself what I call a 'five-minute fiddle' to put in any little details that are urgently lacking. At this stage, the painting is unofficially finished, by which I mean that it needs to sit on a 'simmering' shelf and be looked at in passing. If, after a few days, nothing leaps out at me as being glaringly wrong or missing, the painting is declared finished and is duly signed.

This process may help to keep you on the straight and narrow, but do not resist good, old-fashioned impulse and inspiration. If something grabs your attention just go for it, whether it is a field of poppies you have stumbled upon, or an intricate rose which simply takes your breath away.

I do not apologise for the number of roses that appear in this book. There are more than 120 different species in my garden and every one inspires me. I hope you enjoy them too.

Irises
45.5 x 25.5cm (16 x 10in)

I sketched in the shapes of the main flowers lightly, then blocked in with strong, rich purple, surrounding the area with light creams and pinks to create a strong contrast on the dark-toned paper. This light and dark effect gave the appearance of sunlight and shadow on the subject and needed no further building up or blending.
The main iris was then developed using hard pastel sticks to apply detail over the softer, richer pastels. Note how thinly the pastel is applied on the bottom iris which is just appearing from the shadows, in comparison with the richer impasto effect of the thick colours on the top blooms.

Colours for flowers

The process of choosing colours is closely linked to choosing paper. Paper colour choice determines the mood and impact of the painting, so the pastel colours used to paint the subject need to be clear, vibrant and un-muddied.

With any painting medium, the reason for limiting the palette is to avoid mixing mud. Too many colours will not only look busy and fragmented, but will make muddy mixtures. The same is true of pastels: with flower painting, in particular, it is essential to keep the colours as pure as possible, to try to emulate the purity of nature's colours. I teach my students to try to limit the number of colours in any one painting to about twelve, give or take one or two. This allows for sufficient colour selections for the main subjects, as well as tonal modifications such as lights and darks in warm and cool options.

If you are buying pastels individually to start a set, I recommend seven basic colours: two yellows, two reds, two blues and a brown (below), from which you can mix virtually anything. Extra colours can be added as your skill develops.

Basic palette
These seven colours will allow the beginner to mix virtually any shade: lemon yellow; raw sienna; burnt umber; crimson; light red; ultramarine; Prussian blue.

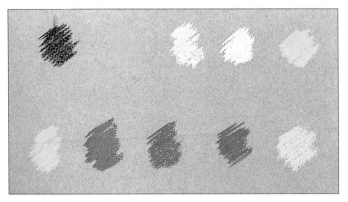

Palette 2: extra tints and colours
These ten tints and colours are a natural extension of the basic palette, and would be good for a beginner: burnt sienna; pale orange; portrait pink; Naples yellow; cadmium yellow; ochre; sap green; purple grey; rose madder; sky blue.

Palette 3: shadow tones
These six dark tones are ideal for creating depth: dark green; indigo; dark grey; blue grey; dark red and another dark brown. Manufacturers' names are not important by this stage; this range of dark tones will add depth to the subject in either warm or cool situations.

Matching pastels and paper

I often contrast the paper strongly with the subject, by choosing a complementary colour: one that is opposite in the colour spectrum, for example red paper with a predominantly green subject, or purple paper to contrast with an orange flower.

Sometimes, a certain colour paper will seem ideal for a subject, perhaps for its similarities rather than because it is a complementary or contrasting colour. It can be inspiring to work on similar-coloured paper, but I am always aware of the need to build complementary colours into a painting so that the result is not too flat. This is not an exact science, in that these complementary colours need not be technically opposite each other on a colour wheel, but each picture should have the appropriate balance of light and dark tones, and warm and cool areas.

The more practice you have with different paper colours and textures, the more confidence you will gain. In time, you will see how the subtleties of paper colour – whether you choose to match or complement your subject – can add an extra dimension to your work.

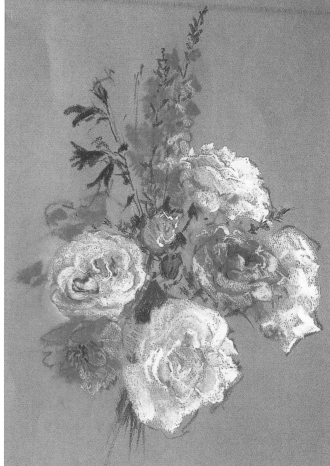

Roses
25 x 38cm (9¾ x 15in)

The purple paper in this example almost matches some of the colours in the roses. I sketched in the outlines of the flowers with a mid-toned pink, then blocked in with appropriate colours, using the main colour of one flower to highlight or shadow others. This limits the colours in the palette, and helps to blend the composition. The green foliage has minimal detail and simply uses one dark, neutral green to pull the flower shapes together.

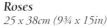

Frühlingsgold rose

An extremely delicate flower is portrayed using a limited palette of five colours, which are added in layers and dampened with water to create subtle washes. The background texture is simply dry pastel on the paper surface.

Indian Bloom
20 x 30cm (7¾ x 11¼in)

This exquisite flower, similar to a poinsettia, caught my eye in a hotel garden in India: its tiny, delicate flower was so strong against the white bracts. Sometimes the delicacy of flowers inspires you to work in greater detail, and I enjoyed the process of developing the intricacies of this small exotic marvel.

Astilbes
29 x 25cm (13 x 9¾in)

Sometimes the paper colour inspires me first, as in this case where I had a bright turquoise paper and wanted a subject that would really vibrate against it. The perfect partner was the bright red of the astilbes, which I blocked in solidly to cover areas of turquoise, otherwise the paper would overtake or 'swamp' the subject.

Potted Plants

Colourful potted plants are a good subject for your first attempt at a flower picture. The plants are easily moved around until you are satisfied with the arrangement, and there is no need to worry too much about the actual pots as they will fade into the background.

I have chosen green paper for this composition, in a shade which roughly represents the central register of green tones. I plan to focus on the central area with the detail fading out and becoming less important towards the edges. I am not looking for contrast; the colour of the blooms is more important than that of the foliage, which will just be a suggestion. I usually integrate a shade of pastel which matches the paper into my palette, and work it into the painting to pull all the elements together. For the same reason, I make sure that each main colour used is repeated as an accent in another area of the picture.

It is a good idea to make a preliminary sketch on cartridge paper, just putting in the main outlines of the arrangement with a very soft pencil. I clip this to the side of the easel as a reminder, so I can just move my eyes to look at it rather than having to peer round the side of the easel every time.

You will need
Potted plants
White cartridge paper
Soft pencil - 8B
Green paper
Pastels
Dry duster or tissue

Tip
Don't be too particular about matching colours to the pastels as you can always match straight on the paper.

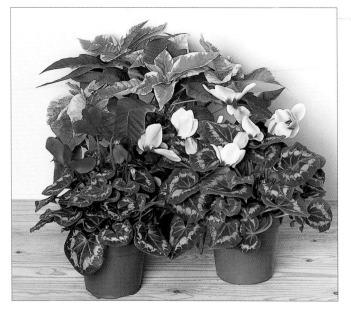

The plants I used

Whether you paint from life or use a photograph, work out where the lights and darks fall before you start your preliminary sketch. Remember that this does not have to be a slavish representation of your source material – you can add more flowers and vary the colours as you like.

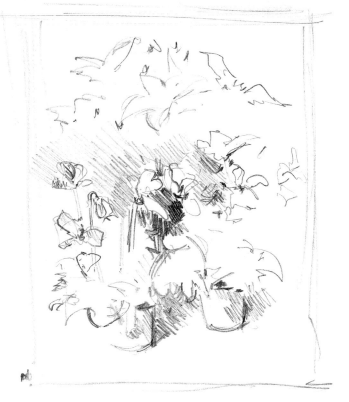

1. Working freehand, sketch in a rectangle on white cartridge paper. Make a preliminary sketch of your plants, putting in just the main marks and using a very soft pencil – 8B is ideal.

*Use a small dish or a
polystyrene tray to
hold the pastels
for a painting
as you work.*

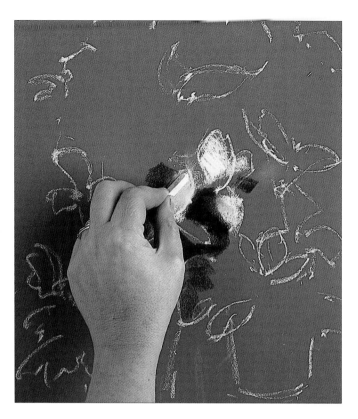

2. Put in a rough guide in white pastel, working in from
the outside to make sure the composition fits on the
paper. Suggest the darkest and lightest areas in black and
white – I call it 'putting in the oomph early'. Remove
any loose pigment with a dry duster.

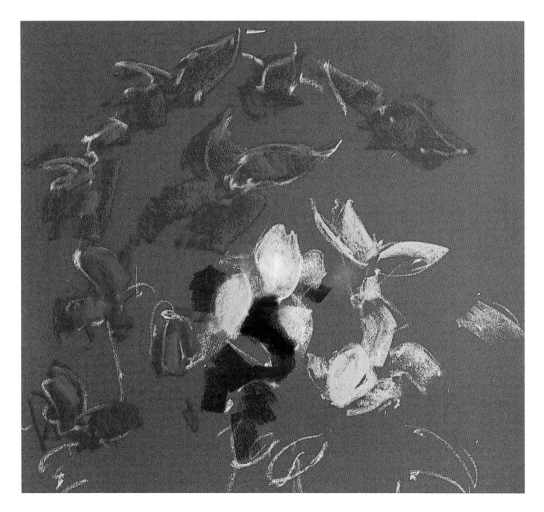

> **Tip**
> *Do not give up on your
> painting just as it is
> becoming interesting.
> Pastel is very forgiving:
> it is easy to adjust or
> deepen colours at any
> time, if you are not
> happy with the effect.*

3. Block in the main
colours of the flowers,
picking the different
pastels by eye and keeping
them in a small dish so
you can pick them up
again easily.

133

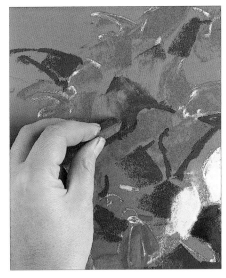

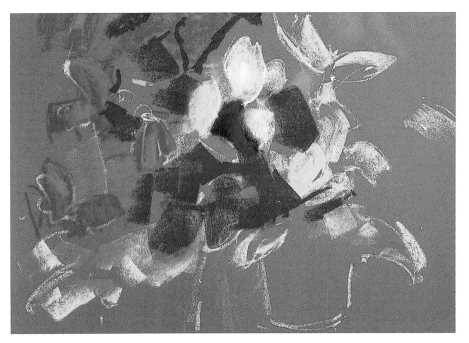

4. Add the green tones, adjusting them until the balance is right, and remembering that the paper represents the mid-tones. Pick out the flower shapes in dark green.

5. The foliage should be cool to contrast with the hot pink flowers, so add blue to tone it down where necessary.

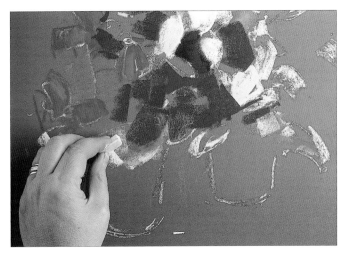

6. Work over the whole area of your picture, making sure the main areas of colour are correct.

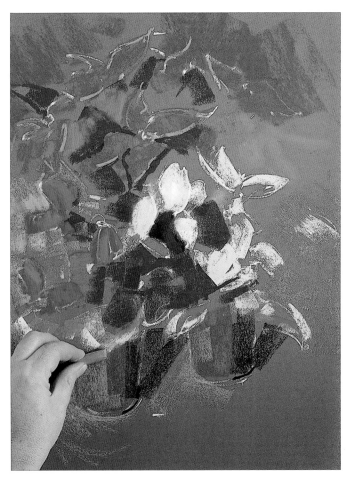

7. Create atmosphere around the subject using tones from your palette. Block in the pots, incorporating some of the flower tones to link the different elements of the picture.

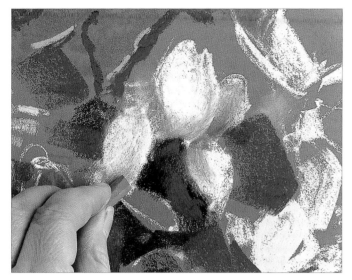

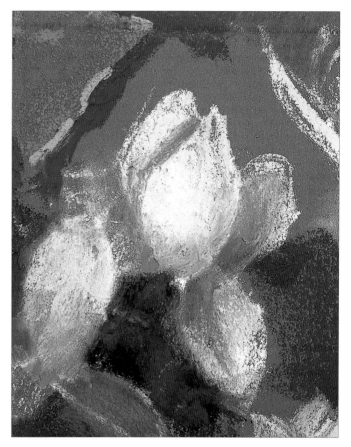

8. With a very light touch and using a deep pink pastel, add detail to the pale cyclamen in the centre of the picture.

9. Create shadow on and around the blooms with the blue that was previously used to tone down the lower foliage.

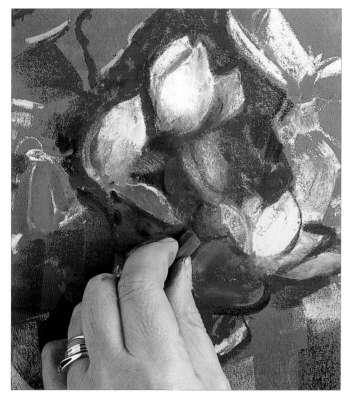

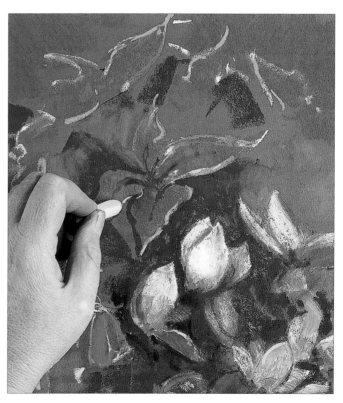

10. Build up the detail around the flower to make it appear to stand off the paper.

11. With light cream, put in the detail of the poinsettias in the central area of the painting.

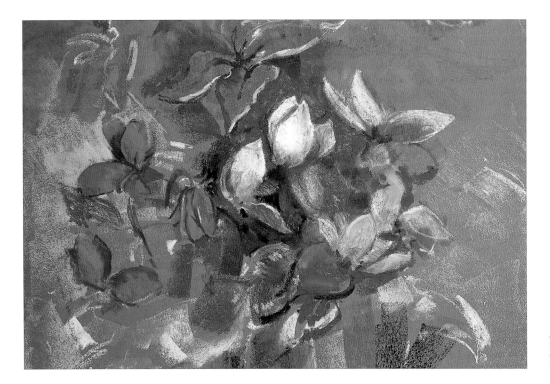

12. With dark green and blue, work on defining the leaves of the plants.

13. Go back to the outside of the picture and work over it to soften the details, rubbing gently with your fingertips in places to merge the pastels.

14. Work round the whole of the outside of your picture in the same way. Take a good look at the composition as a whole and work over it, tidying up details and adding touches of pastel if necessary.

Opposite: the finished painting

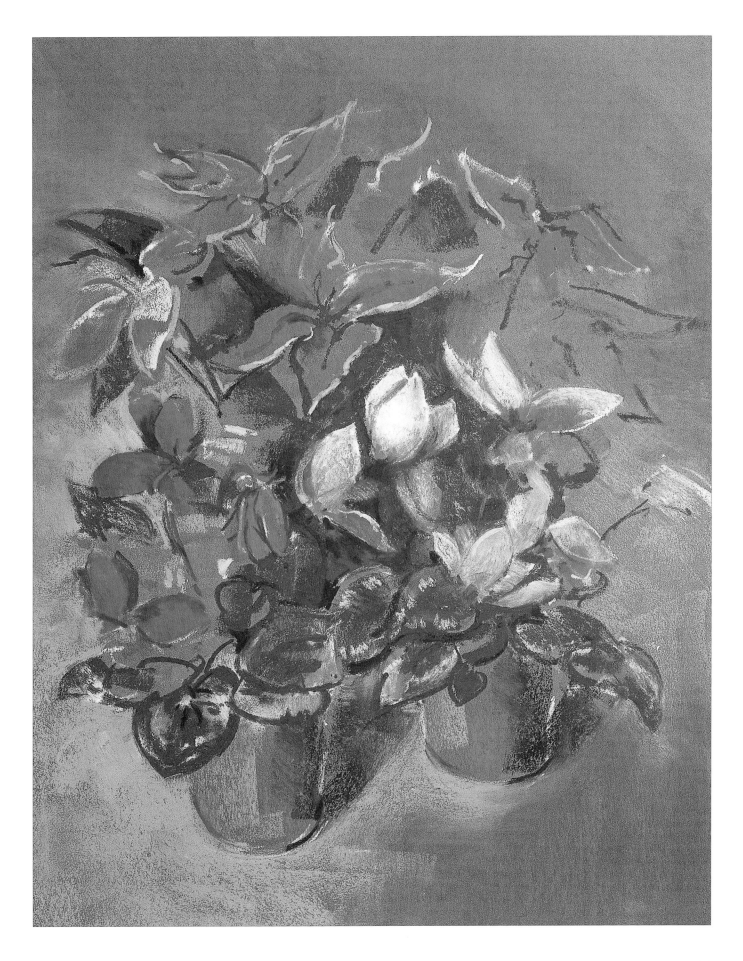

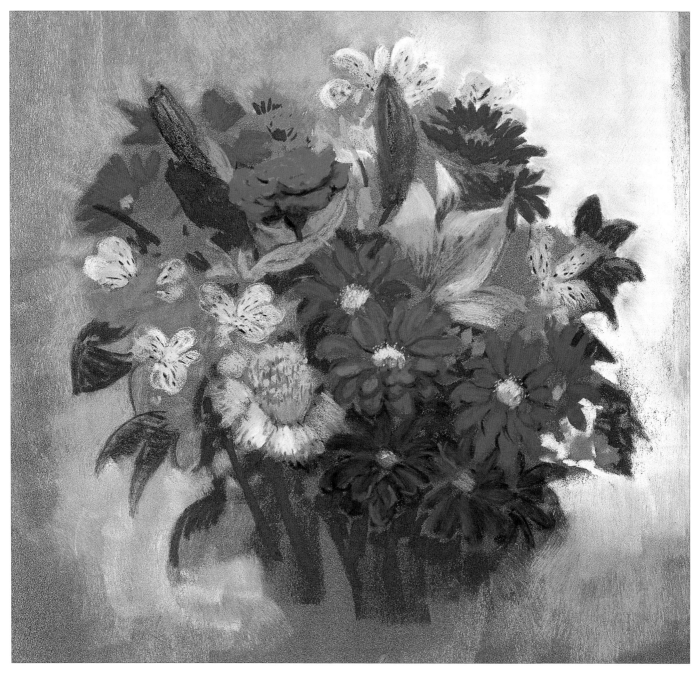

Spring Bouquet
31 x 31cm (12¼ x 12¼in)

As soon as I saw this bouquet, I wanted to use blue paper to balance its vibrant, hot colours with coolness. I chose dark blue so I could accentuate a full range of lights and darks. The flowers had more than enough contrasts and complications, so I faded out the subject at the stems: trying to paint vases can detract from the flowers. The solid flower shapes were blocked in boldly with the main flower colour, then glazed with a much lighter touch to add light, shadow, and adjust the colour. The background was blocked in boldly where the dark blue was too strong, then faded out by glazing lightly towards the outer edges to merge into the paper colour.

The picture (right) in dry pastel on pastel card shows how a limited palette – just lilacs and greens – keeps the theme simple. I blocked in the outer shape of the pot and plant, then divided it into individual flower stems. The heads are basically oval, so I created the 'bulk' form of each head first using light and dark contrasts, then built up the stems, including tonal values behind the plant to create atmosphere. The pot was actually silver, but I kept the same palette colours so there was unity between plant and pot. Finally, I broke down the large flower heads, suggesting the individual 'star' shapes of the florets, mainly on the front flower.

138

Photographs & sketches

Botanical painters, who have to study their subjects at close range, really have to work from life. Any artist will tell you that it is best to work from life if possible, but how often do you have the chance to paint in your garden? Even when you are visiting beautiful gardens, there is so much to see that there is often not much time to paint, and the weather does not often permit such luxuries. Besides, if the weather is that good, it is also good enough to catch up on gardening – as I often find when I go outdoors to sketch my roses! The advantages of using photographs are obvious, as long as we do not try to copy, which can be the biggest problem! With a looser style, good-quality photographs, backed up by sketches, are often easier to work from.

Source photograph

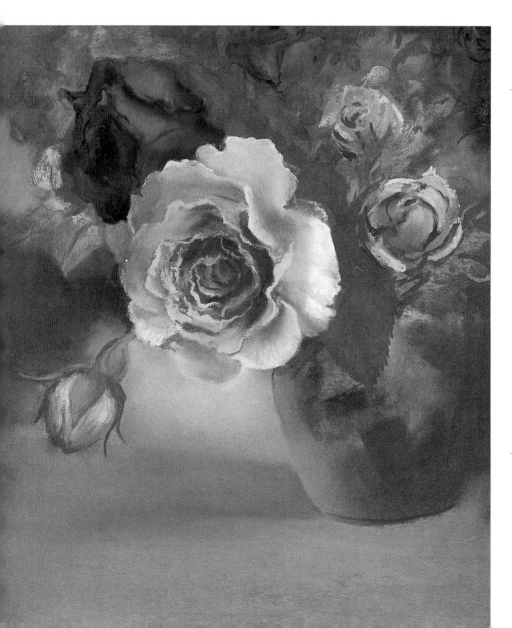

The Last Roses
29 x 24cm (11½ x 9½in)

The roses, left, were painted entirely from a photograph, because they began to droop almost as soon as I brought them in. I started the painting from life, but took the photograph as soon as they began to droop and finished it later. I used part of the composition and did not attempt to copy the blooms or the detail slavishly.

Opposite
Daisies
38 x 29cm (15 x 11½in)

For the picture opposite, I used a reference photograph along with a quick tonal sketch done at the same time. I like to do a preliminary tonal sketch if possible: it is invaluable not just for working out tones, but for trying out various compositions. My main concern in a study like this is to determine which shapes are light against dark, and which are dark against light; in other words, counter-change. I really believe that working this out first makes the process of completing any painting easier.

Tonal sketch

Source photograph

Garden

For this project, which is based on photographs of my neighbour's garden, the paper has been chosen to match the deep brown of the fence. Take care that you do not let the colour of the foliage overwhelm the colour of the paper. Remember that, for balance, you should pick a light and a dark tone of each colour in the painting. There are two different types of red in this painting, a bright, crimson red for the nasturtiums and a more muted burgundy red which is used on the fence. Each of these should be paired with a lighter tone. Bear in mind that when you are working quickly across the painting to put in the tones as I do, it is a great help if you can do it from life.

You will need

White cartridge paper
 for rough sketch
Pencil
Brown paper
Pastels

The photographs I used for reference. Only part of the bottom photograph was used.

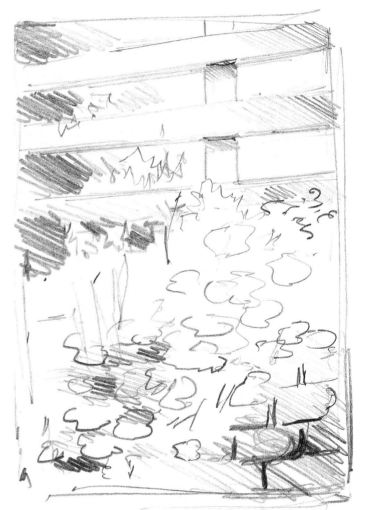

1. Referring to the source photographs, make a preliminary sketch.

142

My palette for this project

2. Referring to the outline sketch, transfer the main shapes of your picture to the paper using yellow pastel.

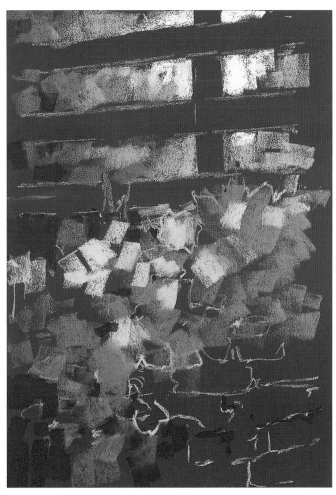

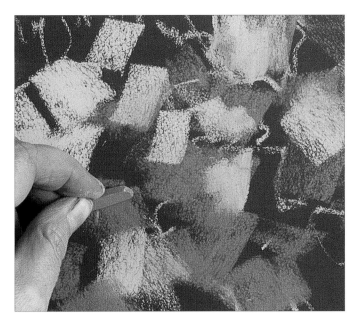

3. Using the pastels flat on the paper and two shades of green, roughly block in the mass of foliage. Scatter touches of green across the rest of the picture.

4. Add a range of blues, distributing the pale and dark areas evenly. To balance the composition, include a light and a dark variation of each blue.

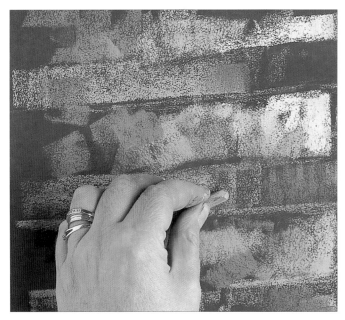

5. Put in the fence using light and dark red tones, holding the pastels flat to block in colour and using the ends to define the edges of the bars.

6. Block in the tones of the wall, using the same light and dark reds as were used for the fence.

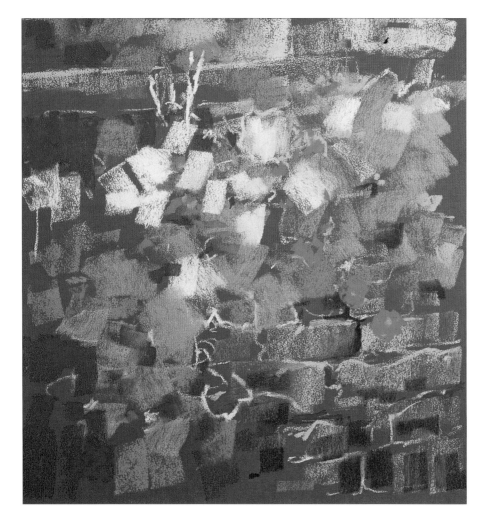

7. Referring to the source photograph for guidance but not being too pedantic, put in the bright reds of the flowers.

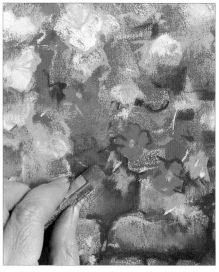

8. Go in on the centre of the picture and sharpen up the detail, using mid-green and blue.

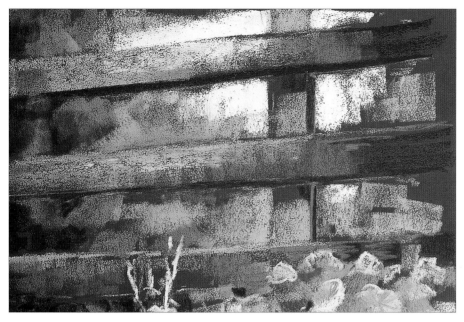

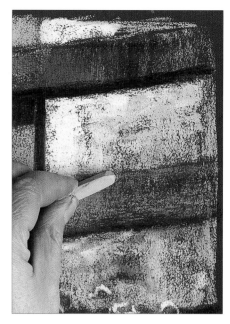

9. Warm the dark area of wood using pink pastel held flat against the paper. Add a touch of sky blue pastel to the fence to soften it and link the elements across the painting.

10. With blue pastel, glaze over the fence posts to take out the strong contrasts and unite the different areas.

Glazing (see step 10) is making marks with the pastel held flat, working lightly. This allows one colour to be dragged over another to create a colour mix.

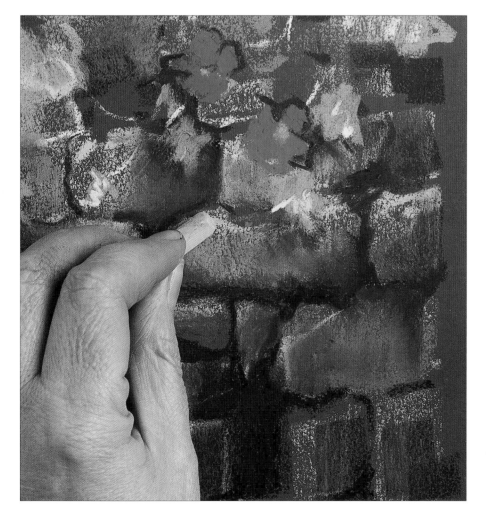

11. Use a little brown to tone down the blue on the wall. Blend the colour in by rubbing gently with your fingertips. Using the same brown, sharpen up the detail on the wall.

12. Rub dark blue pastel across the lower left corner of the picture to glaze across the foliage and pull the different elements together.

13. Go in on the centre of your picture and sharpen up the detail where necessary.

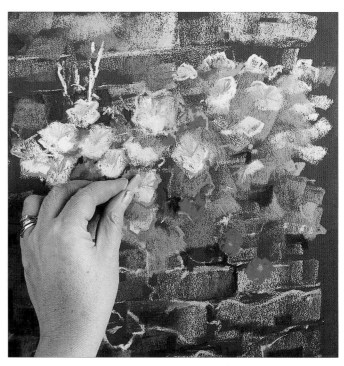

14. Add a few hints of dark red to the bottom left-hand corner to suggest flowers nestling in foliage. Glaze the area with a mid-toned pastel.

15. Stand back from your picture and make the final adjustments. The massed foliage looks too busy in places so use a mid-toned green to tone it down. The top left-hand corner has not been touched since it was first blocked in.

Opposite
The finished painting.

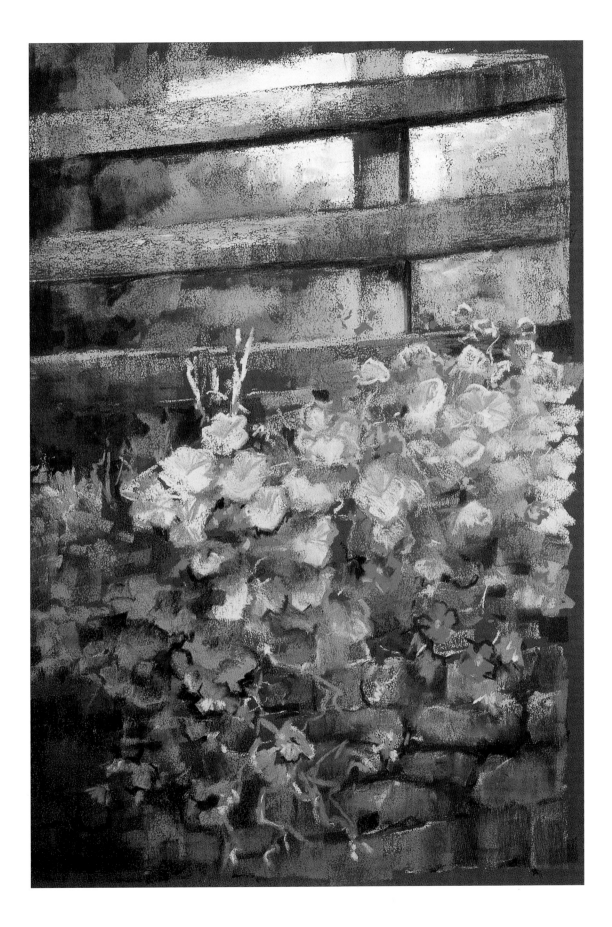

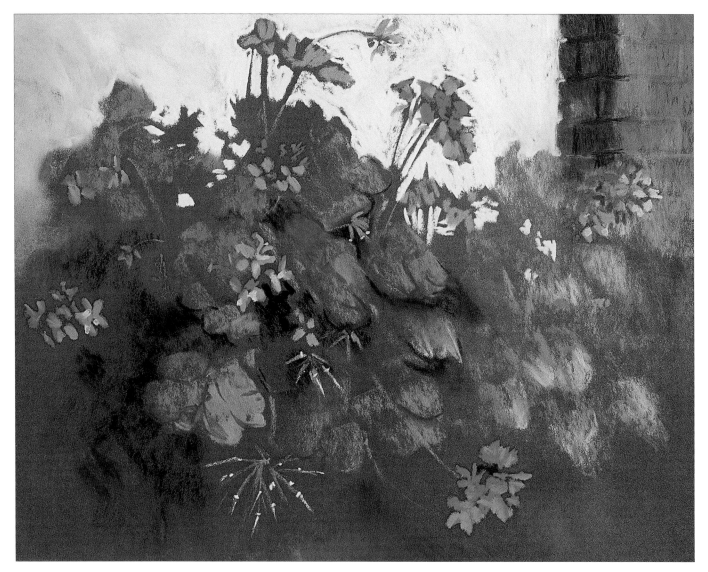

Cipressini Geraniums
23 x 30.5cm (9 x 12in)

The stunning mass of geranium leaves and bright pink flower heads against a sunny background attracted me to the dark green sandpaper, which allows the foliage to 'disappear' into the paper colour. In contrast, impact was created by blocking in the sunshine behind the subject, making the negative shapes of individual leaves stand out. The pink flowers were then placed, using a soft, bright shade in easy directional strokes to indicate petals. A few dashes for seed heads and highlights on the flowers were all that was needed to suggest detail.

Delphiniums
38 x 27cm (15 x 10¾in)

Counter-change was a particularly strong theme to this subject, and the reason it inspired me to paint, glimpsing the spectacular delphinium against the strong dark rich greens of the Scots pine tree in my garden. I placed myself particularly to view the light shape of the flower against the dark tree, and used the feathery effect of the surrounding foliage to soften the composition and break up the shapes towards the outer edges.

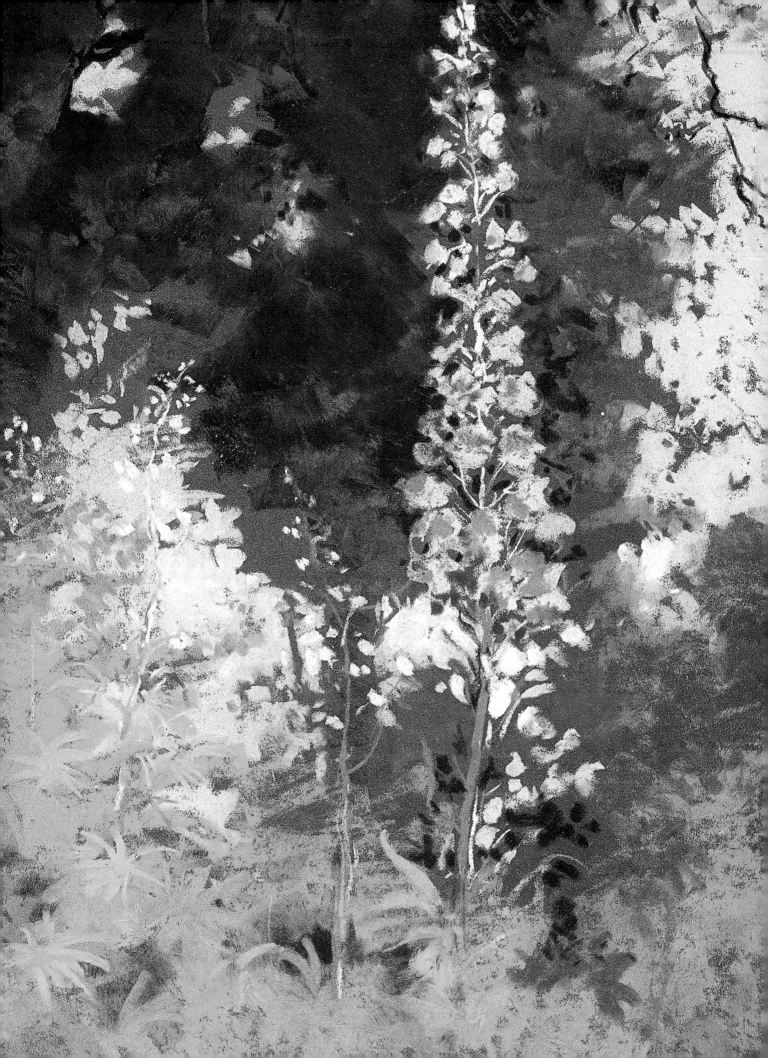

Adding water to pastels

To add or not to add: that is the question! Some subjects, particularly flowers, and usually those traditionally painted in watercolour, lend themselves to the addition of water. It is fun to use watercolour techniques, whether for the ethereal delicacy of roses, or for solid, vibrant colour like petunias or geraniums. You also have to decide whether to use 'wet' water or 'damp' water: when a wet brush is applied to pastel it dilutes the colour and creates washes, just as in traditional watercolour painting. If, however, a damp brush (with the water blotted out so it is just damp) is applied, the colour is intensified and can be used to create solid blocks of intense colour.

All pastels are made from pure pigment, but the binders added determine how effectively they can be diluted. Some cheaper brands are 'bolstered' with clay and kaolin so the proportion of pure pastel is lower, and solubility is affected. Expensive pastel ranges are generally softer, more crumbly, and far more receptive to wetting. Some will positively melt into pure colour. Experiment to discover whether pastels will dilute successfully. You should also test your paper to make sure it is receptive to water. Watercolour papers are ideal, but some pastel papers will buckle and some, like pastel card, may disintegrate. If you prefer to work on dark-toned papers, your colours must be opaque: mix body colour with white to create solid colour, as transparent colour will simply soak into the paper. I often block in the subject of a painting first using gouache or acrylic paint, before using pastel and water.

Rose sketch

If you use soft pastels on watercolour paper, there is no reason why you cannot simulate the techniques of watercolour painting and build it up in transparent layers, while retaining the white paper if the subject demands it. In this sketch I have built up the form of the peach flower by wetting each layer in turn, then applying more colour where I wanted a more intense tint. I applied fresh colour while the previous wash was still damp, creating a stronger, more vibrant effect which is similar to wet-in-wet watercolour techniques.

Petunias

The flower shapes were blocked in solidly with strong pink, tones added with paler pink, and the colour intensified using a damp brush. The green area is dry pastel applied with a lighter touch, showing the texture of the paper.

Italian pelargoniums

Similar marks on rough watercolour paper show how the effect can change with different paper types. Added water creates a denser, more painterly effect.

Mixed media

If pastel is simply blocked on to paper then diluted with water, it is technically still pure pastel. If you under-paint, or add gouache, watercolour, or acrylic paint, your work becomes mixed media.

With pure pastel, layers of pastel can be alternated with layers of washes or water, diluting and building up colour, from light to dark. Each layer can be added to when dry, although I have achieved some interesting effects by putting dry pastel on top of damp pastel. The main feature of this practice is that pastel diluted with water becomes paint and therefore does not smudge. This means you do not need fixative to make your painting permanent – though I never use fixative! Watercolour washes can be used to produce dramatic backgrounds to pastel flowers. These can be put down first and the pastels worked in while they are still wet (see *Lilies*, right). They can also be applied after the pastels (see *Gladioli*, below).

Lilies

I had only ten minutes to capture these flowers, so I put wet washes of pink and green watercolour over the page, then worked the pastel lilies into the damp colour. The white lilies were painted in negative by retaining the white paper, and the texture of the foliage was suggested by building it up with dry green pastel.

Under-painting

With gouache, I prefer to under-paint. I sketch in the outline of my subject with a faint watery solution of colour, then block in tonal opposites with solid gouache. When I have divided the composition into the main light and dark proportions, I develop the rest of it with pastel, dampening it in areas to solidify or intensify colour. Acrylic paint is also ideal for under-painting, as it dries very quickly leaving a flat colour to work on top of. It is permanent when dry, so the pastels can be wetted to create further layers and glazes. I use acrylics thinly, adding white to create opacity, and ensuring there is sufficient 'tooth' left on the paper to grip the pastel on top.

Gladioli
51 x 36cm (20 x 14¼in)

This demonstration shows how watercolour washes can be applied around blocks of pastel, to create a background which surrounds and interacts with the subject. The top flower has been painted with negative shapes in watercolour, whereas the right-hand gladiolus has been applied on top of watercolour background washes to create depth. Although loose and sketchy, this work has plenty of action and atmosphere.

Rose Bouquet

For this demonstration, I have deliberately chosen a soft, pale-coloured paper to enhance the delicacy of the roses, and to help to intensify the vibrant colour of the main rose, on which water is used to strengthen the colour. I want to keep the overall impression very soft with the roses merging into the pale blue paper, so I will retain a soft edge to the outer roses.

<div style="border:1px solid">

You will need
White paper
Pale grey paper
Soft pencil - 8B
Pastels

</div>

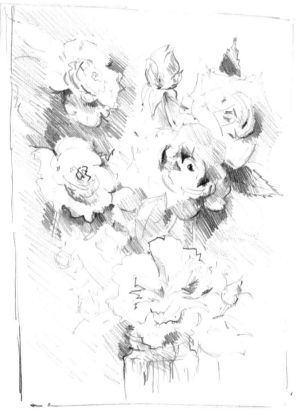

1t may be useful to secure the source sketch and photographs around the edge of the easel as you work for reference.

1. Referring to the source photographs, make a rough sketch plan.

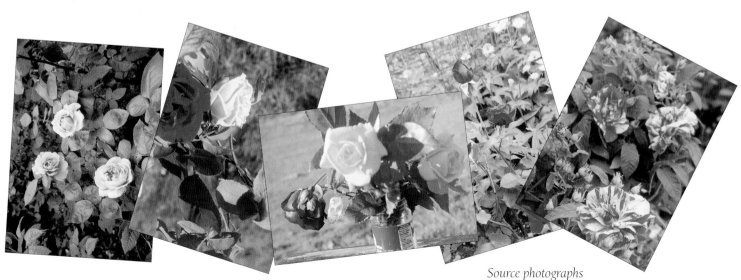

Source photographs

152

My palette for this project

2. Sketch in the outlines of your composition using white pastel.

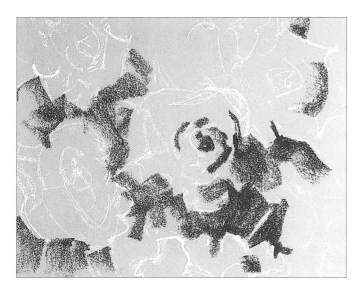

3. Put in some dark tones using dark blue/grey.

4. Put in the mid-green tones, choosing the shade by trial and error and remembering that on pale paper colours can look far darker.

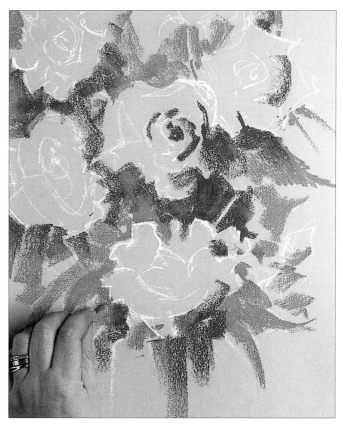

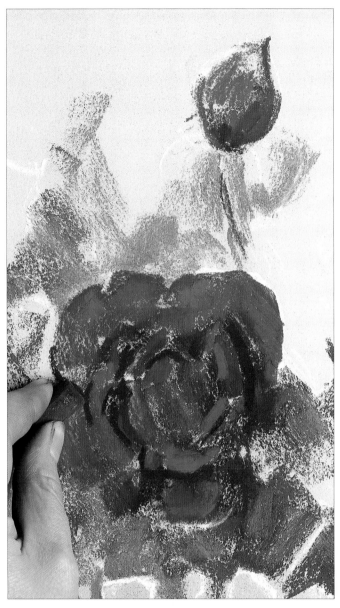

5. Using dark and mid tones of red and pinky-red, block and sketch in the details of the Etoile de Hollande rose.

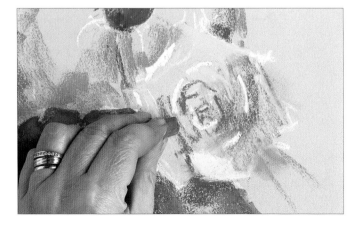

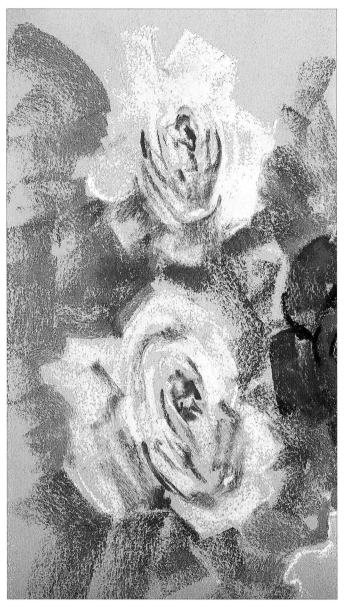

6. Using pale and deep shades of pink, place the colours for the two pink Penny Lane roses on the left, then add yellow to tie them in with the other roses across the page.

7. Put in the single yellow rose using bright and pale yellow tones. Add touches of red to tie it in with the other flowers across the painting.

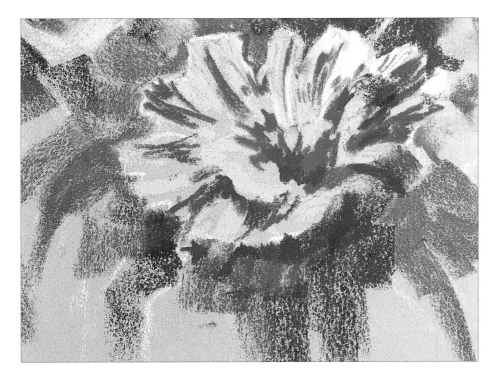

8. Add the Rosa Mundi in the foreground using two shades of pink pastel. Add red to link it with the other roses, and white highlights. Add the yellow centre and accents, which will link it with the single yellow rose.

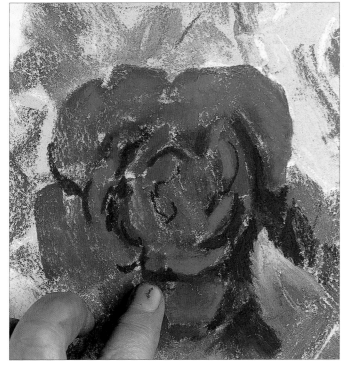

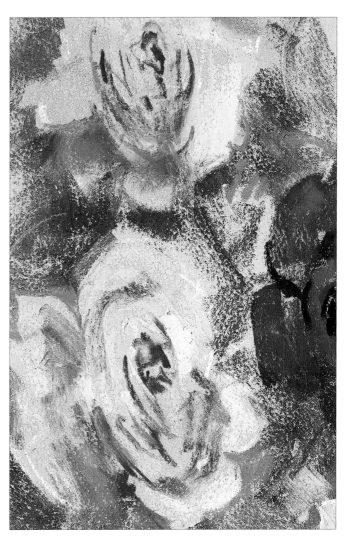

9. Add a little yellow to accent the foliage under the red rose. Put in some touches of red to suggest stems. Rub in some areas to soften the pastels.

10. Put in some blue-grey pastel, very similar in colour to the paper, to help to merge the pink roses into the shadows at the edges.

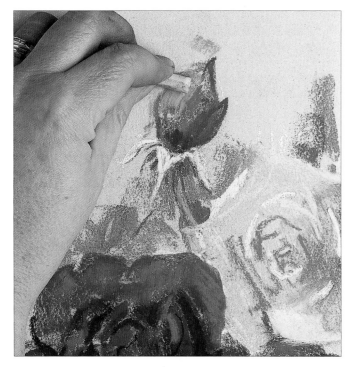

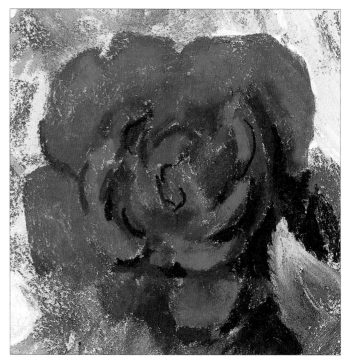

11. Put in a little blue-grey pastel to merge and define the rosebud at the top of the painting.

12. Work over the central rose, thickening up the colour to eradicate the grain of the paper.

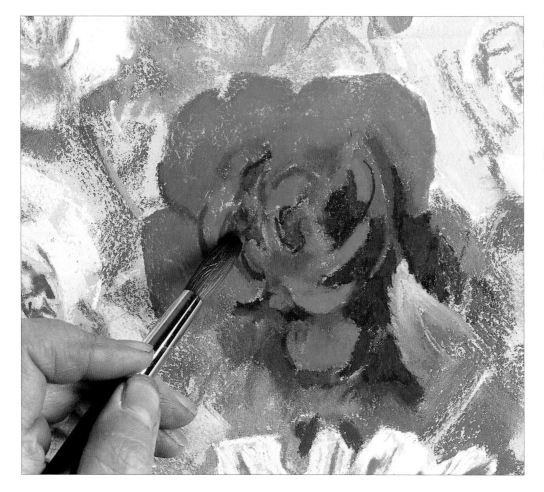

13. Use a paintbrush to add a little water to the rose in the centre of the painting. This will solidify the colour and provide an interesting contrast with the other areas which are grainy. Use a cloth to take off any excess water.

Opposite:
The finished painting.

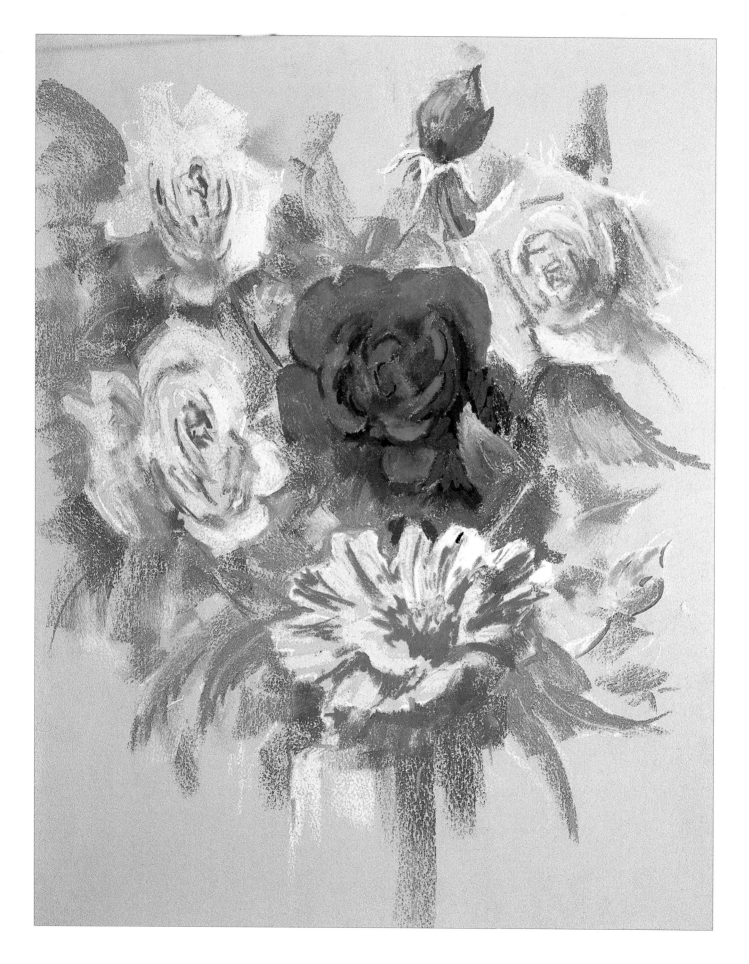

Italian Garden
37 x 26cm (14½ x 10¼in)

Gouache under-painting and pastel

A large, well-stocked garden can be overwhelming to paint. This example shows how to select a small area with a feature i.e. a pergola and concentrate on the play of light and dark.
I used dark paper (blue) and blocked in the lightest tones with pale tints of gouache, using plenty of white for body colour. The flower details are an impression rather than a description.

Opposite:
Hollyhocks at Heale House
43 x 30.5cm (17 x 12in)

Working on rough watercolour paper, I created a background of colour and texture for the beautiful lemon hollyhocks. I built up from thin pastels washed with water, to thicker, more impasto techniques, therefore working from thin to thick paint, and from background to foreground. The hollyhocks were strengthened against the dark window which was blended to a smooth finish.

Index